People

by
Craig A. Finseth

Firwood Consulting, Inc.
St Paul, Minnesota, US

Firwood Consulting, Inc.
1343 Lafond
St Paul MN US
http://www.firwood.net
inquiries@firwood.net

First Printing, January 2016

Copyright 2016 by Craig A. Finseth.
Images copyright 1998-2015 by Craig A. Finseth.

ISBN 978-0-578-17690-1

Preface

This book is a collection of photographs taken by me over the period 2000 through 2015. It includes those whose main focus is people in some way. In all cases, these photographs were taken as the opportunity arose, and they have not been altered in any way (other than cropping). They are ordered (mostly) chronologically.

When I take pictures like these, I try to take them as a snapshot of a larger story...leaving the viewer to create the story.

Of course, in some cases, they are just people being people.

They are here for you to enjoy. Please do.

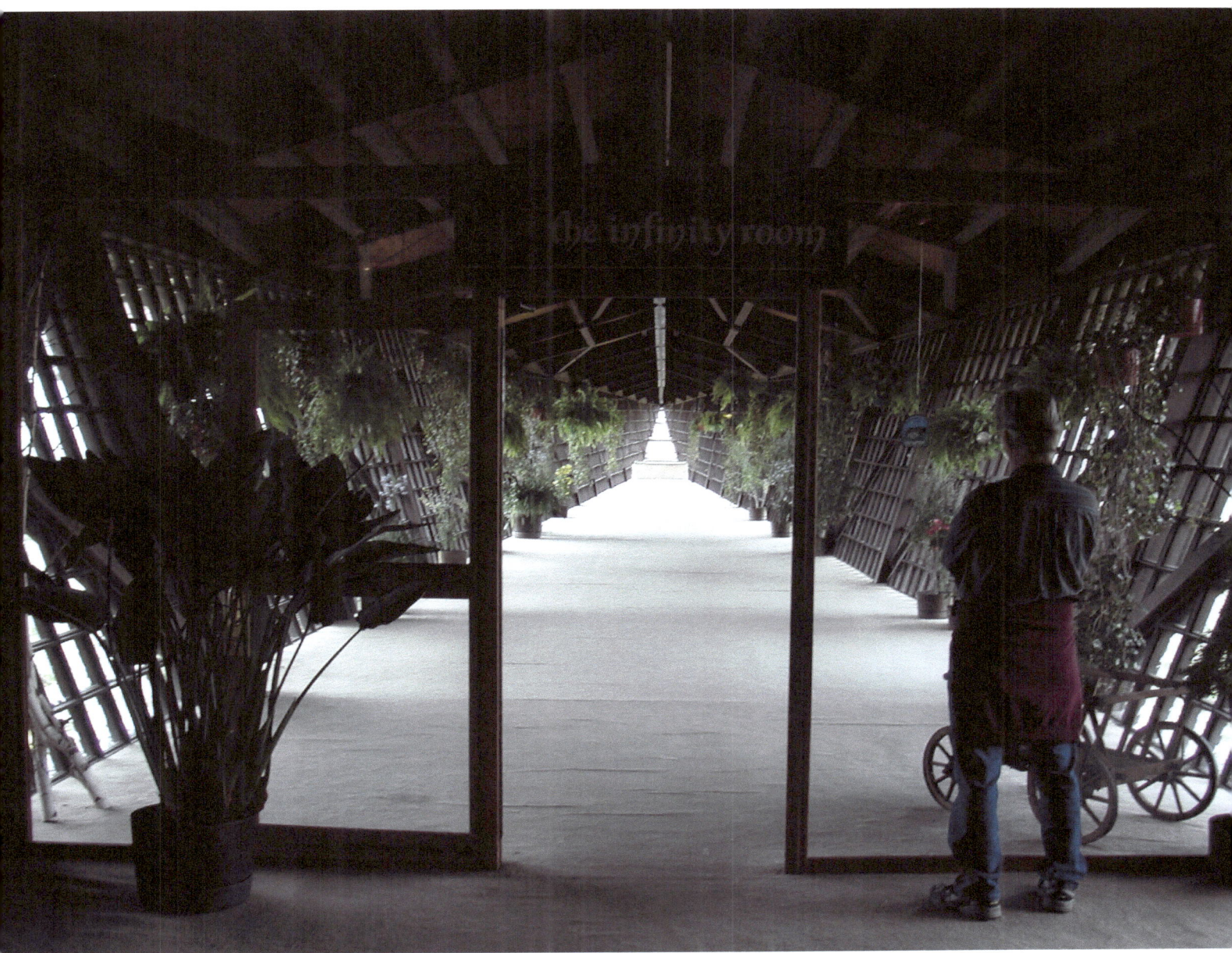

May 2002 – House on the Rock, Spring Green, WI

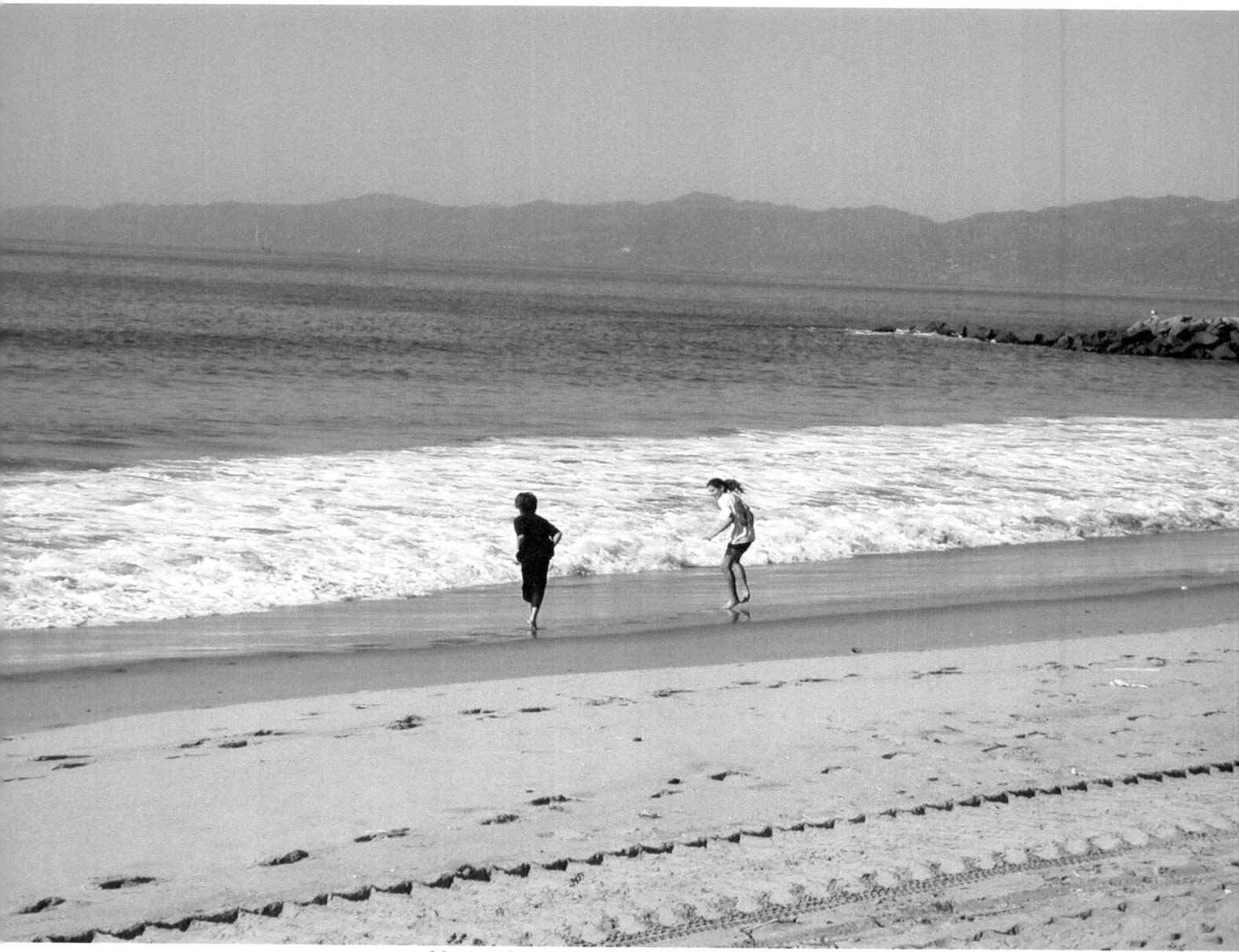

November 2000 – Los Angeles, CA

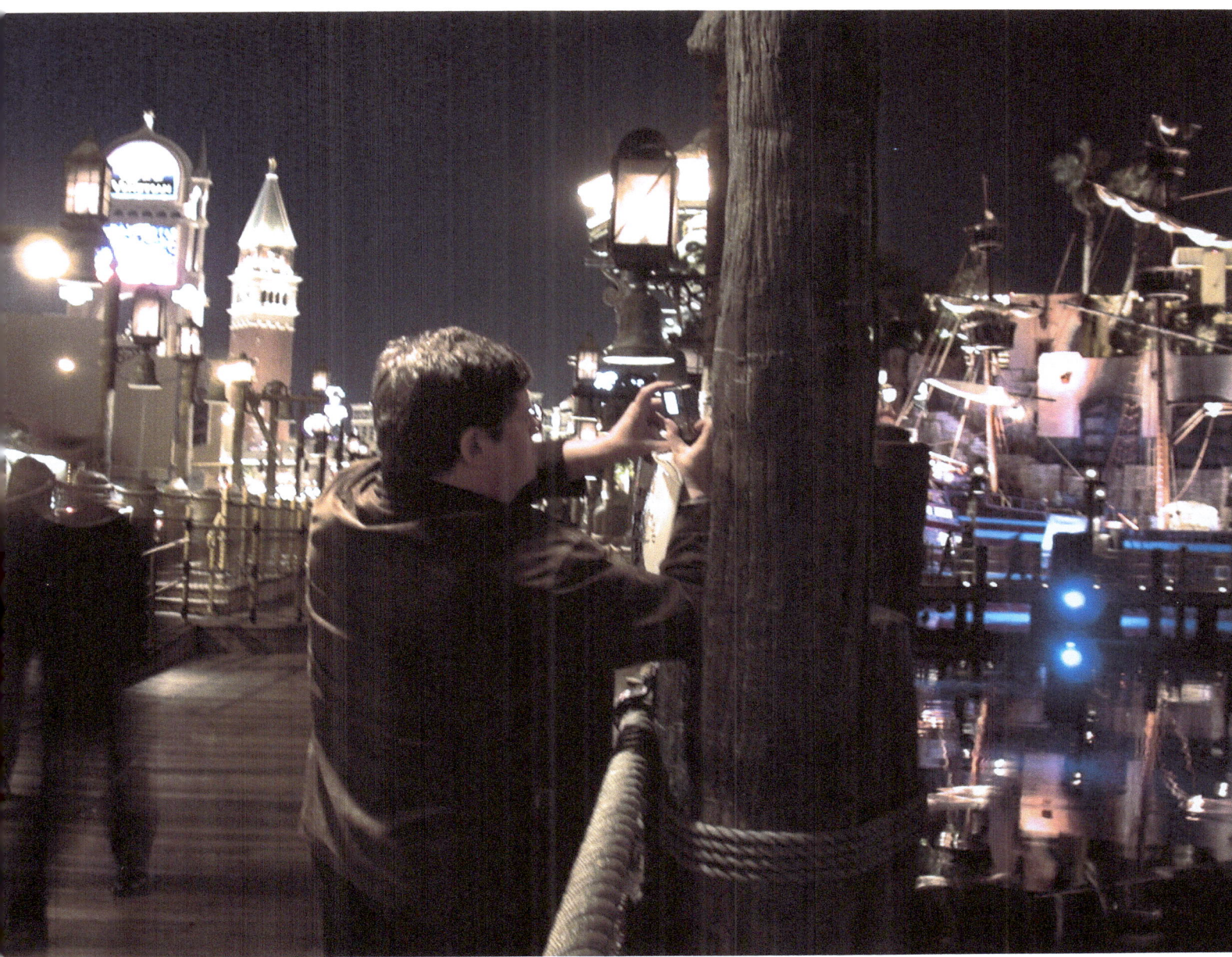
January 2001 – Las Vegas NV

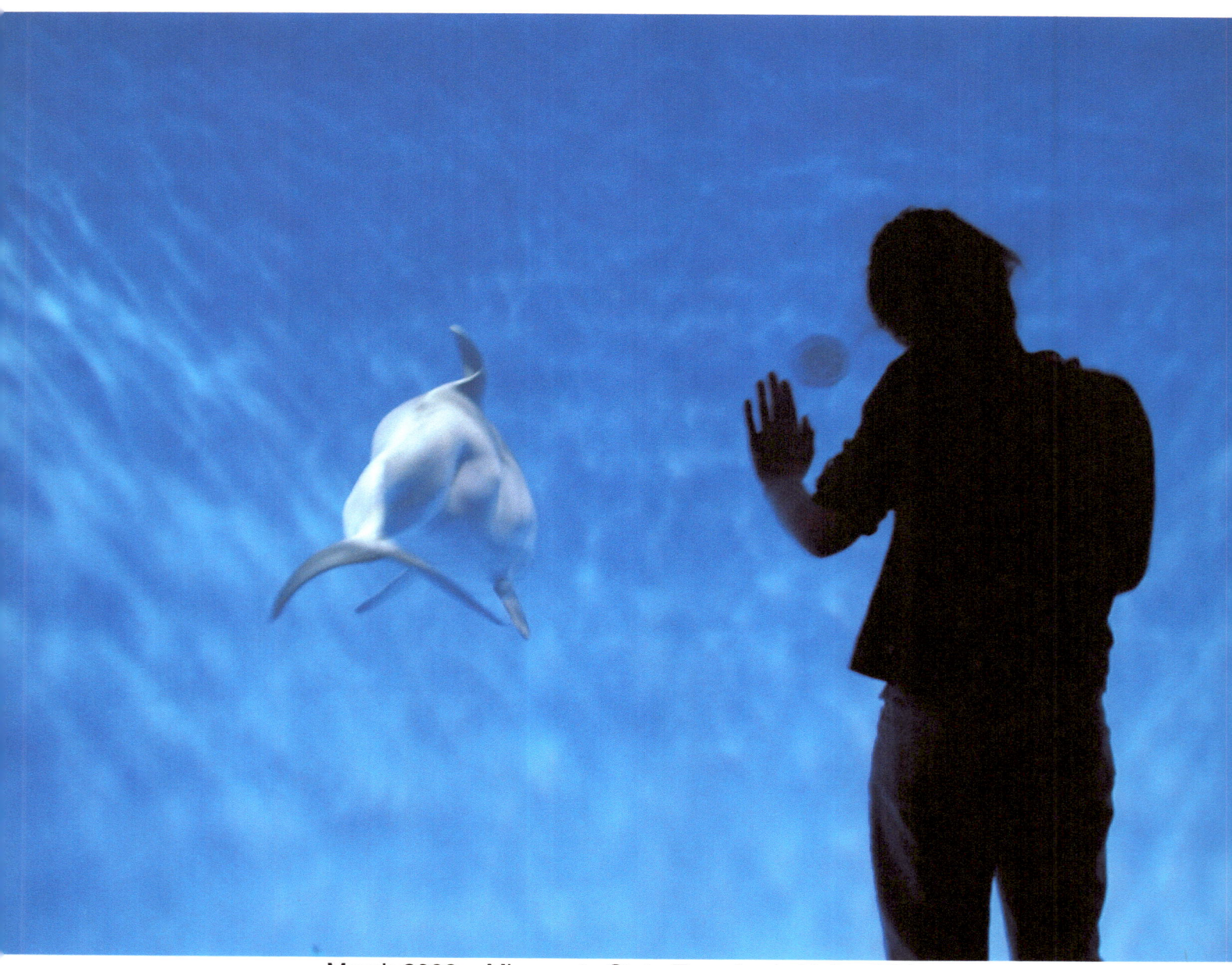

March 2002 – Minnesota State Zoo, Apple Valley MN

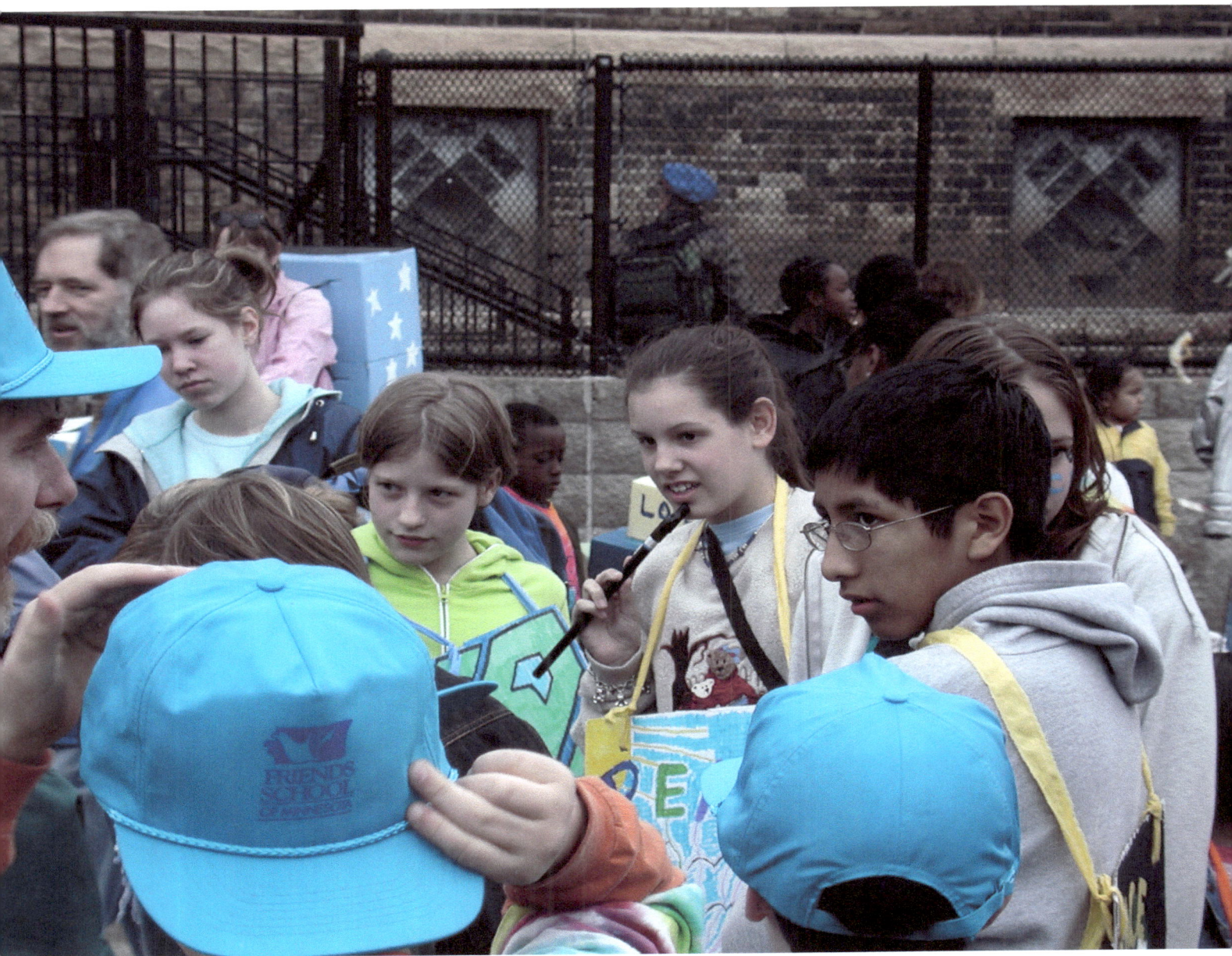

May 2002 – May Day Parade, Minneapolis MN

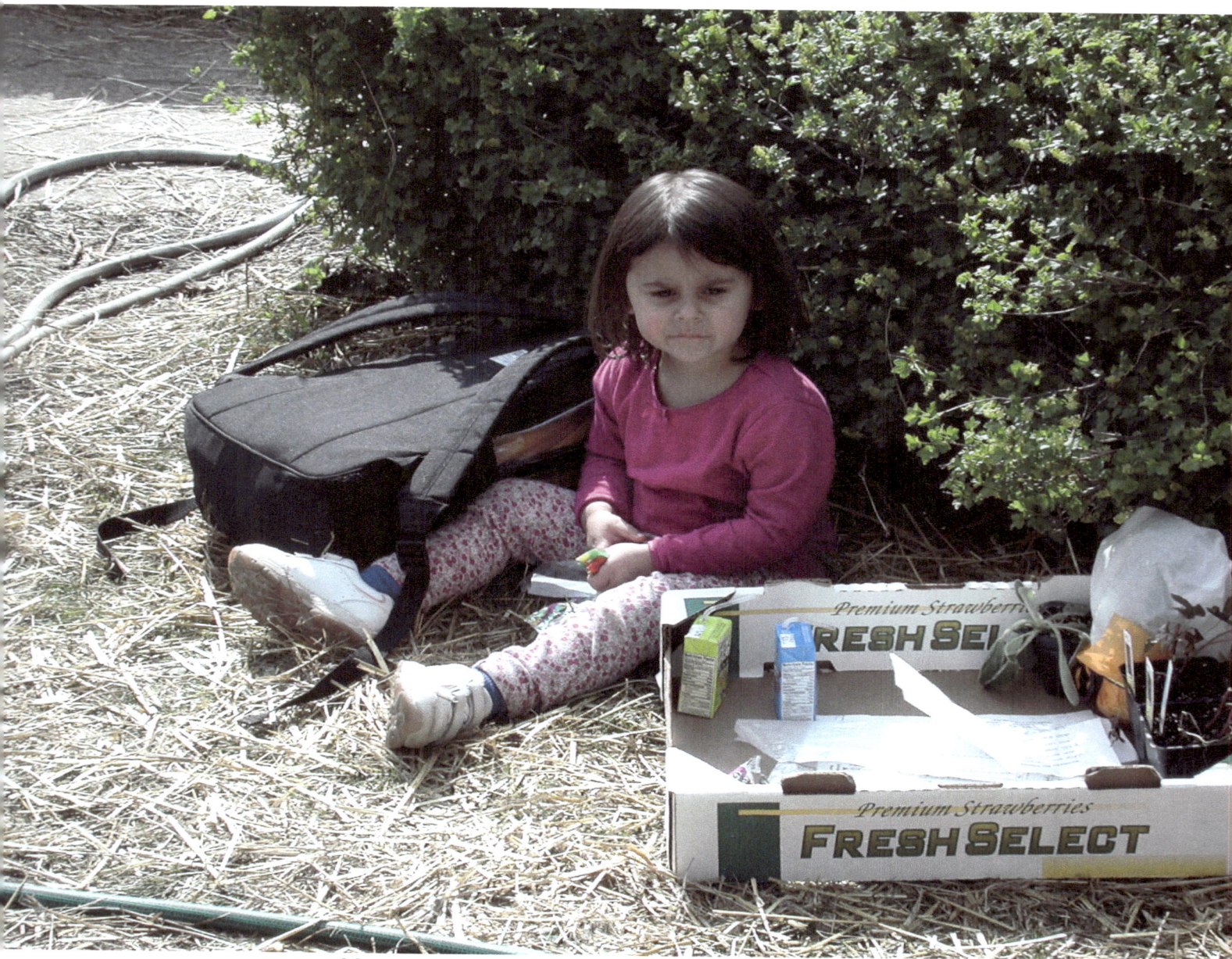
May 2002 – Friends School Plant Sale, St Paul MN

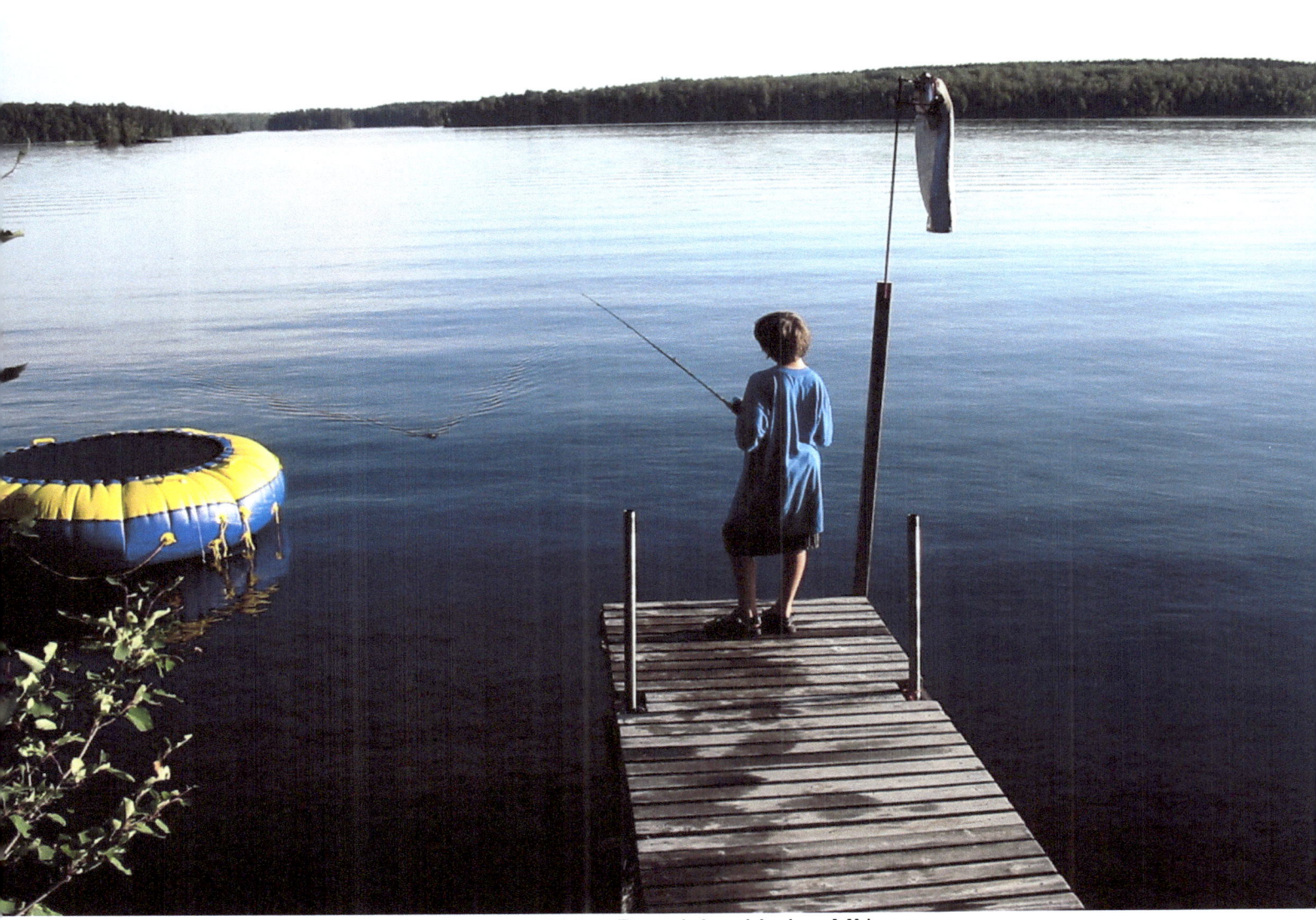

August 2002 – Bear Island Lake, MN

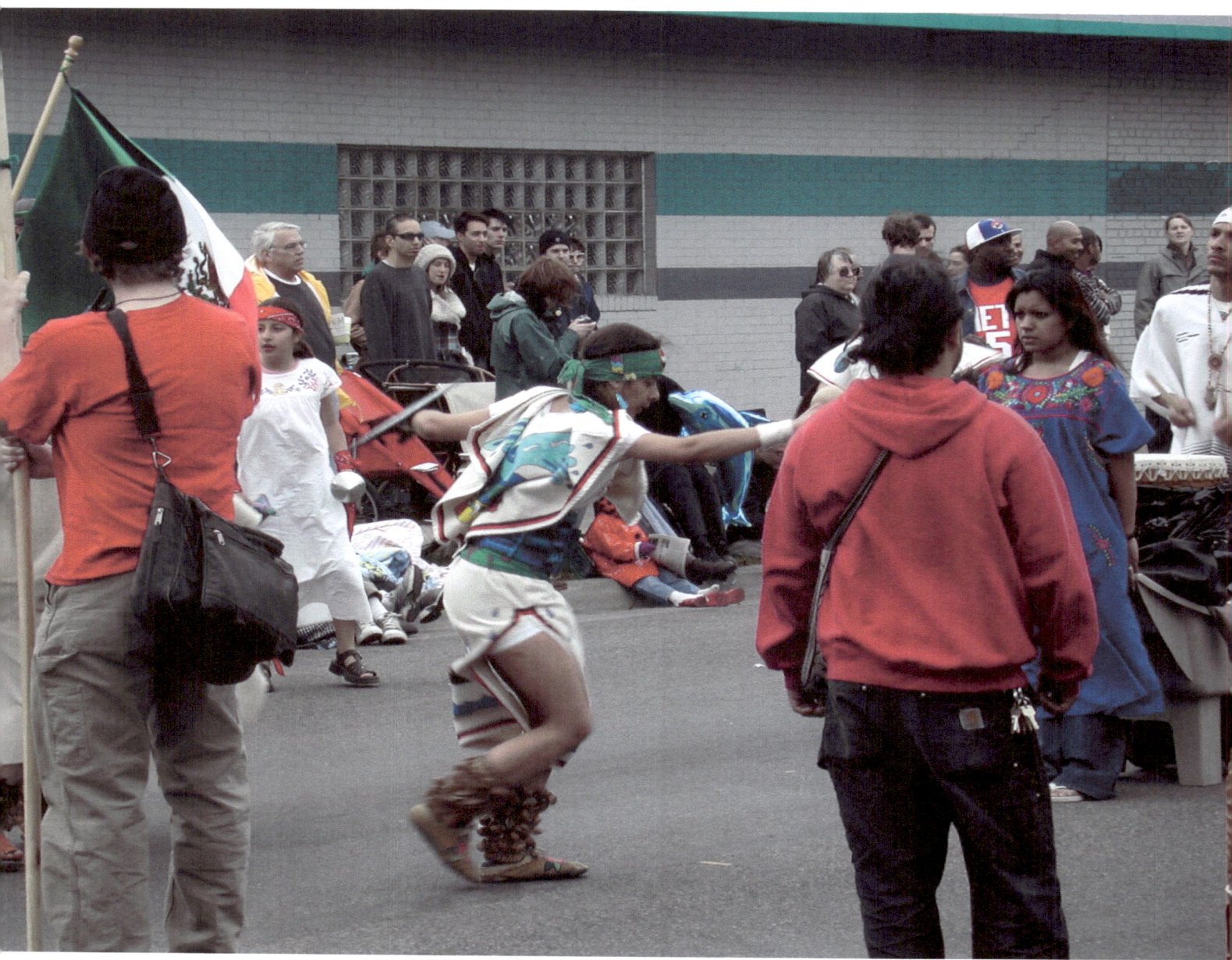

May 2003 – May Day Parade, Minneapolis MN

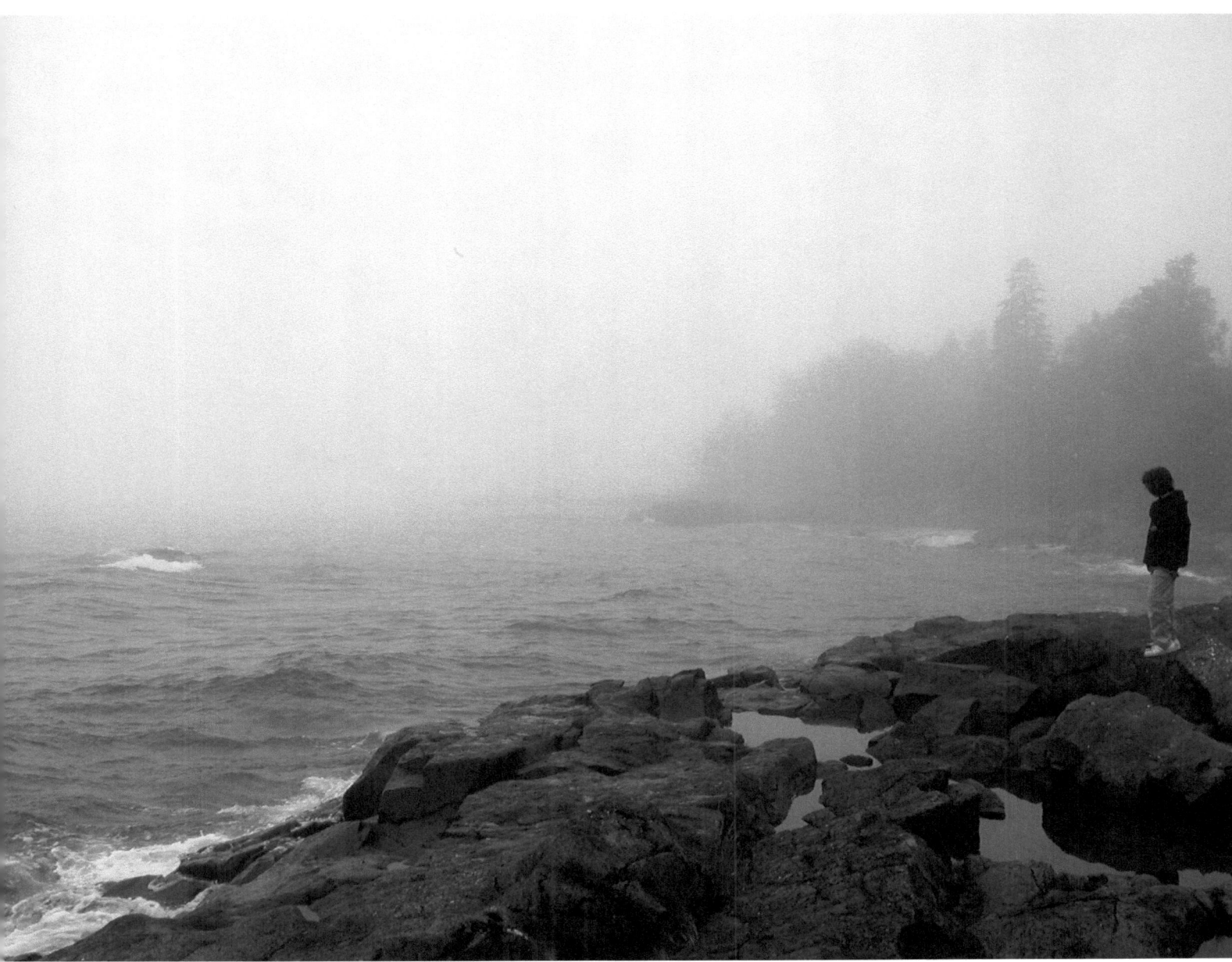

June 2003 – Lake Superior Shore, near Lutsen MN

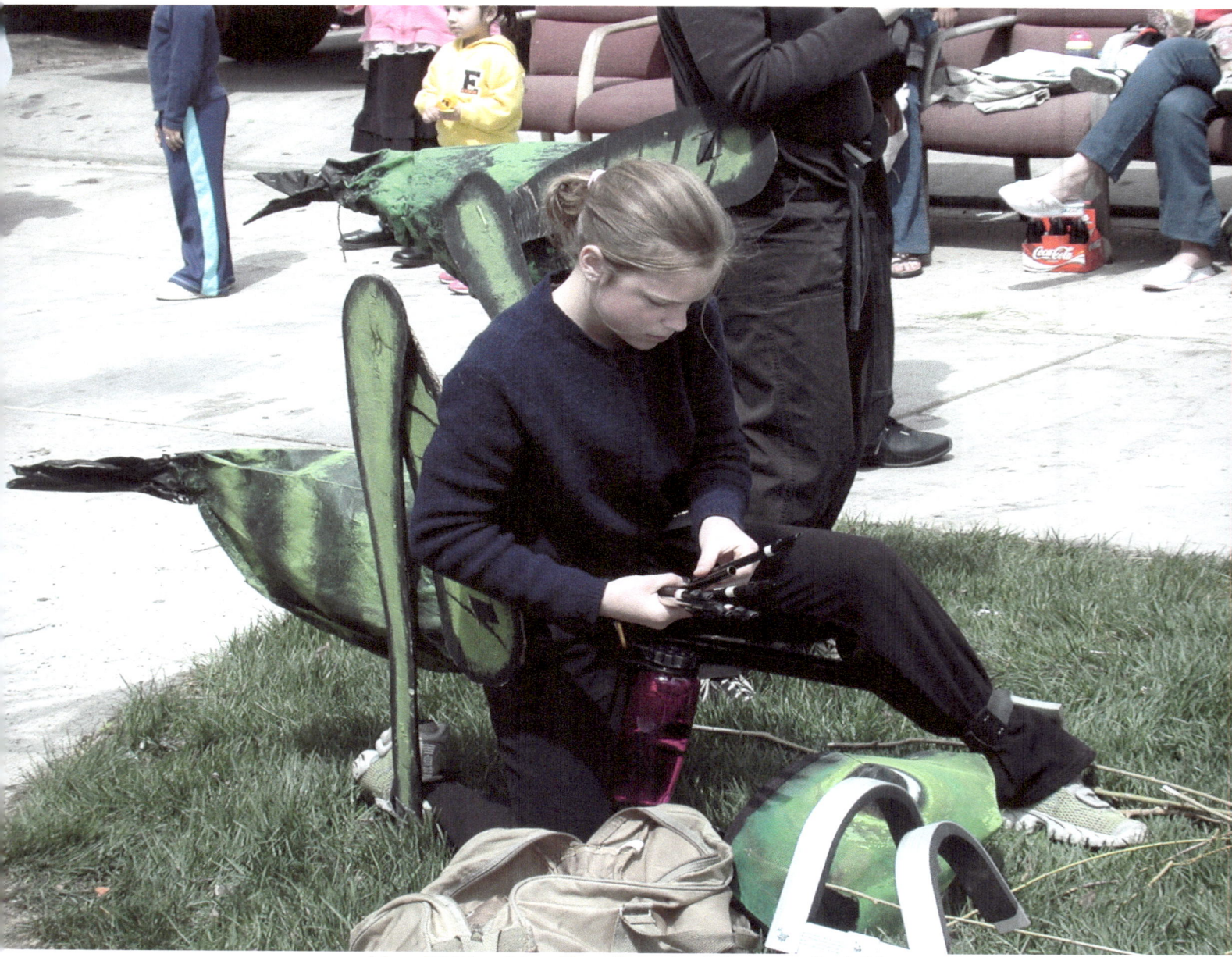
May 2004 – May Day Parade, Minneapolis MN

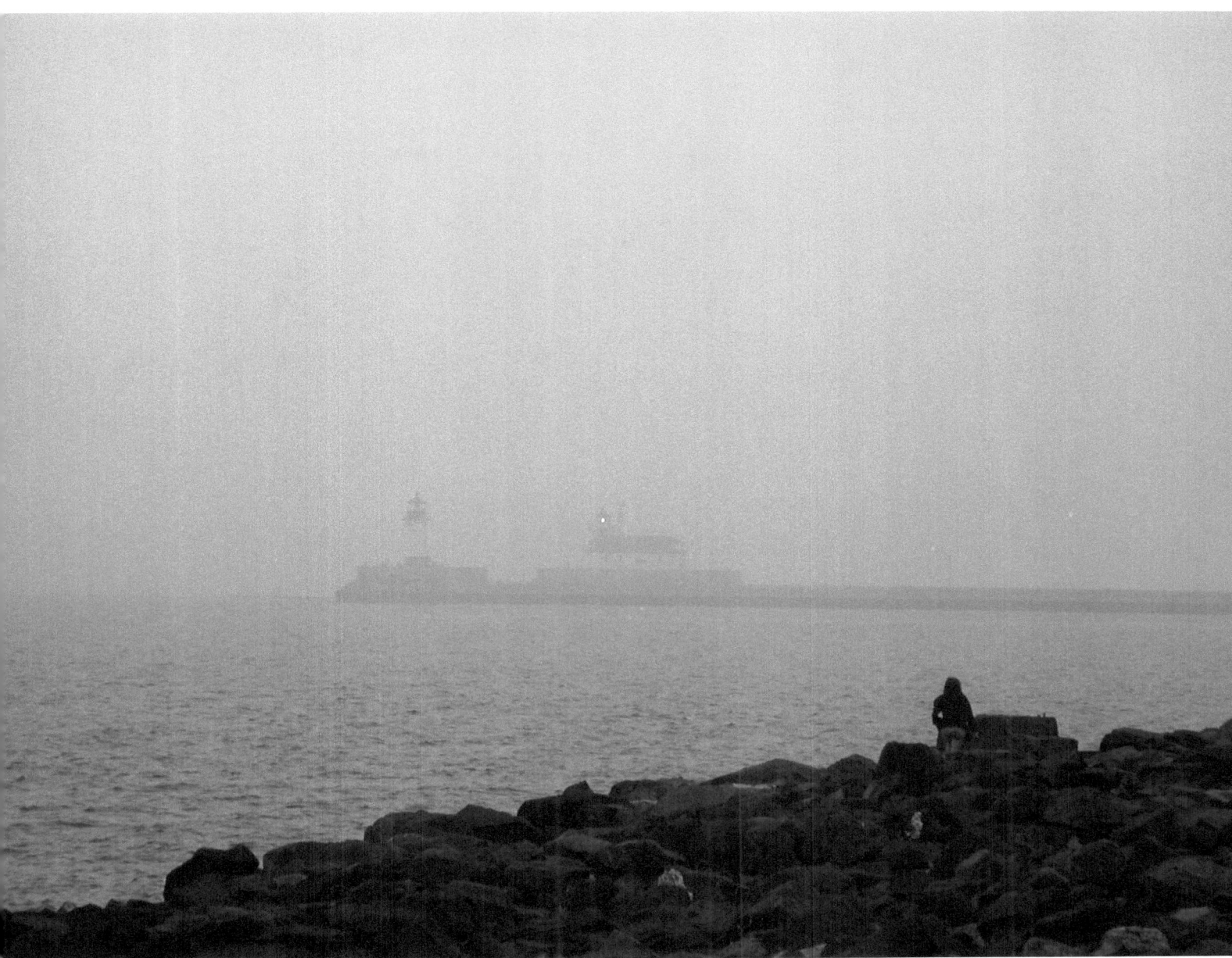

May 2004 – Canal Park, Duluth MN

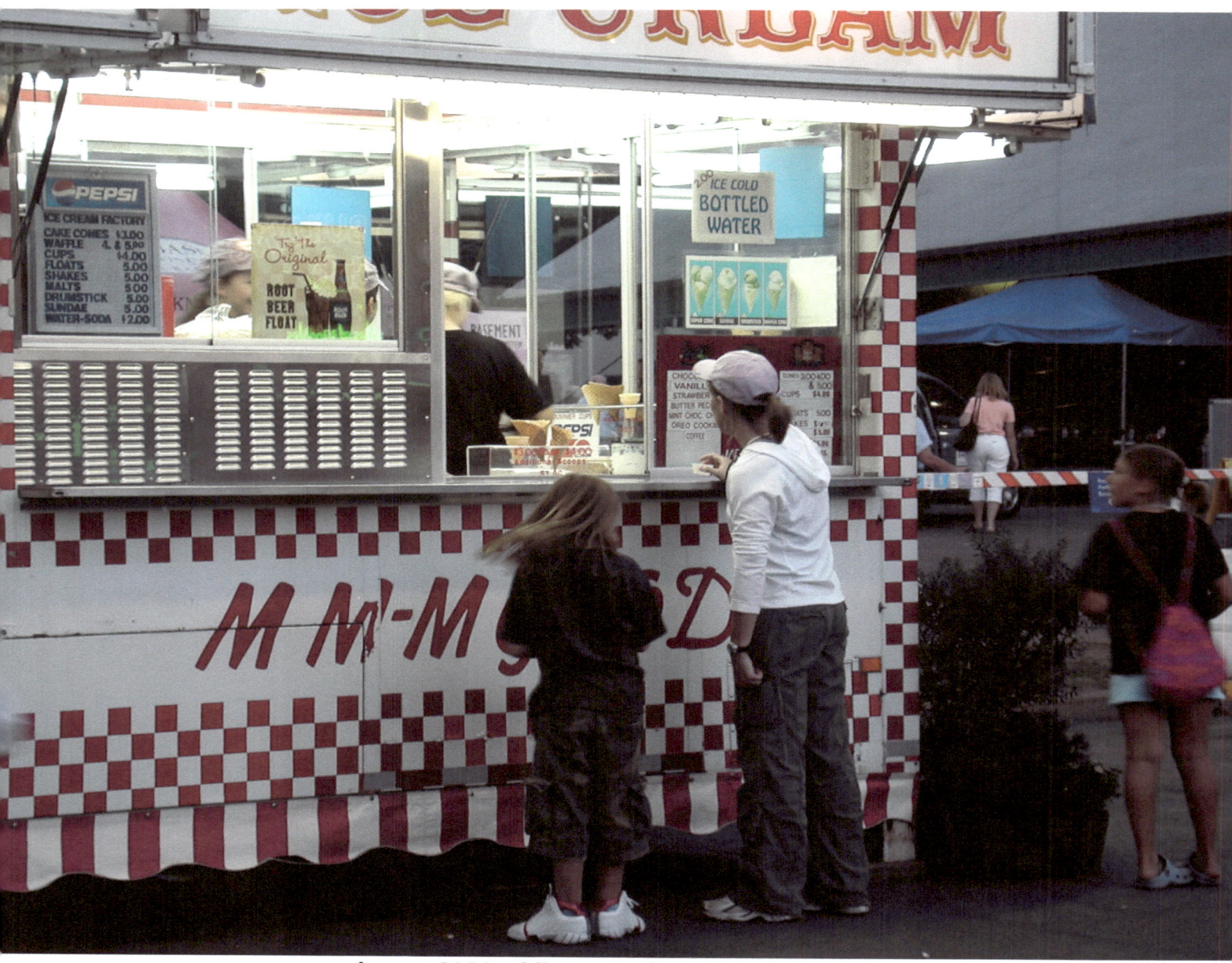

August 2006 – Minnesota State Fair, St Paul MN

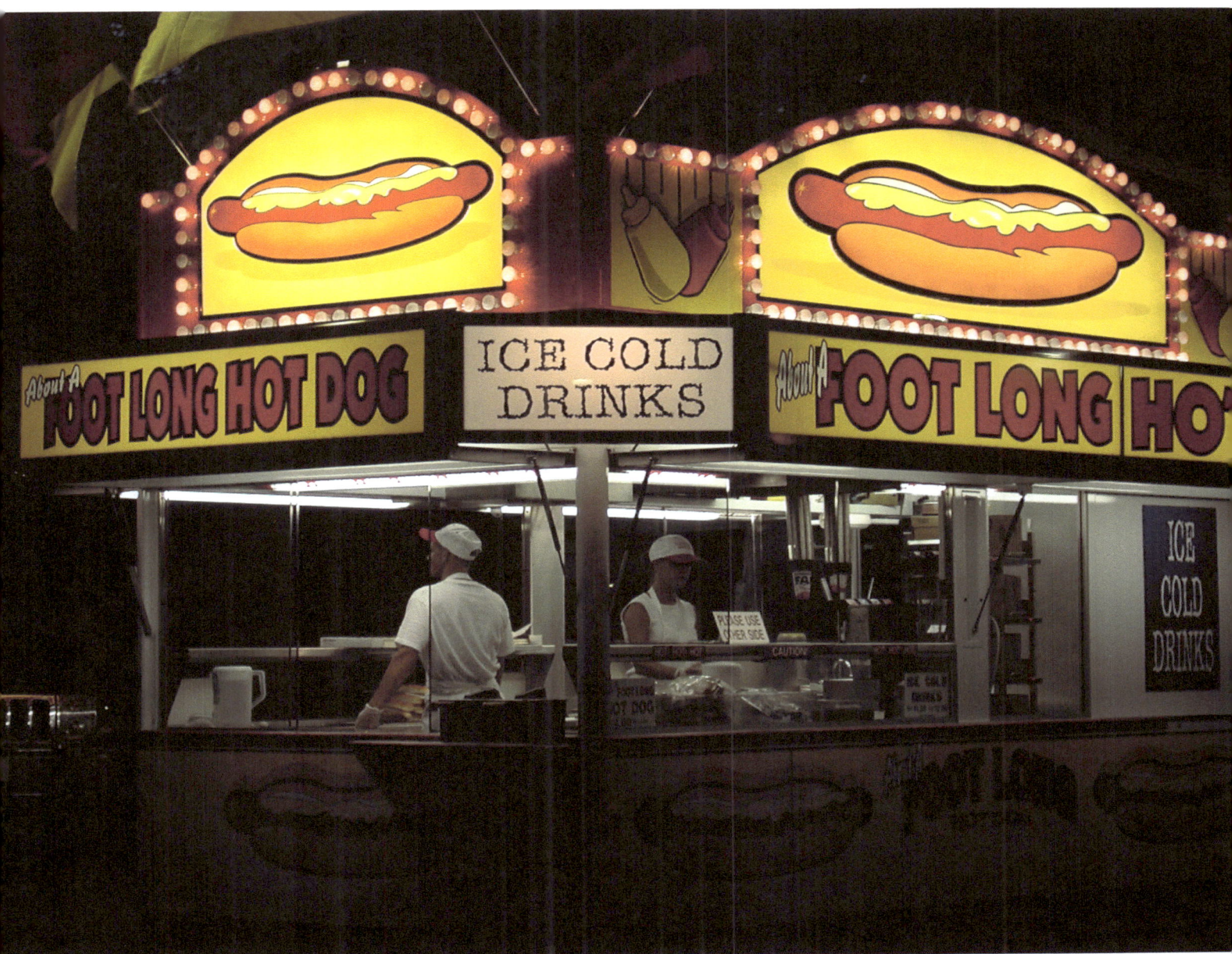

August 2006 – Minnesota State Fair, St Paul MN

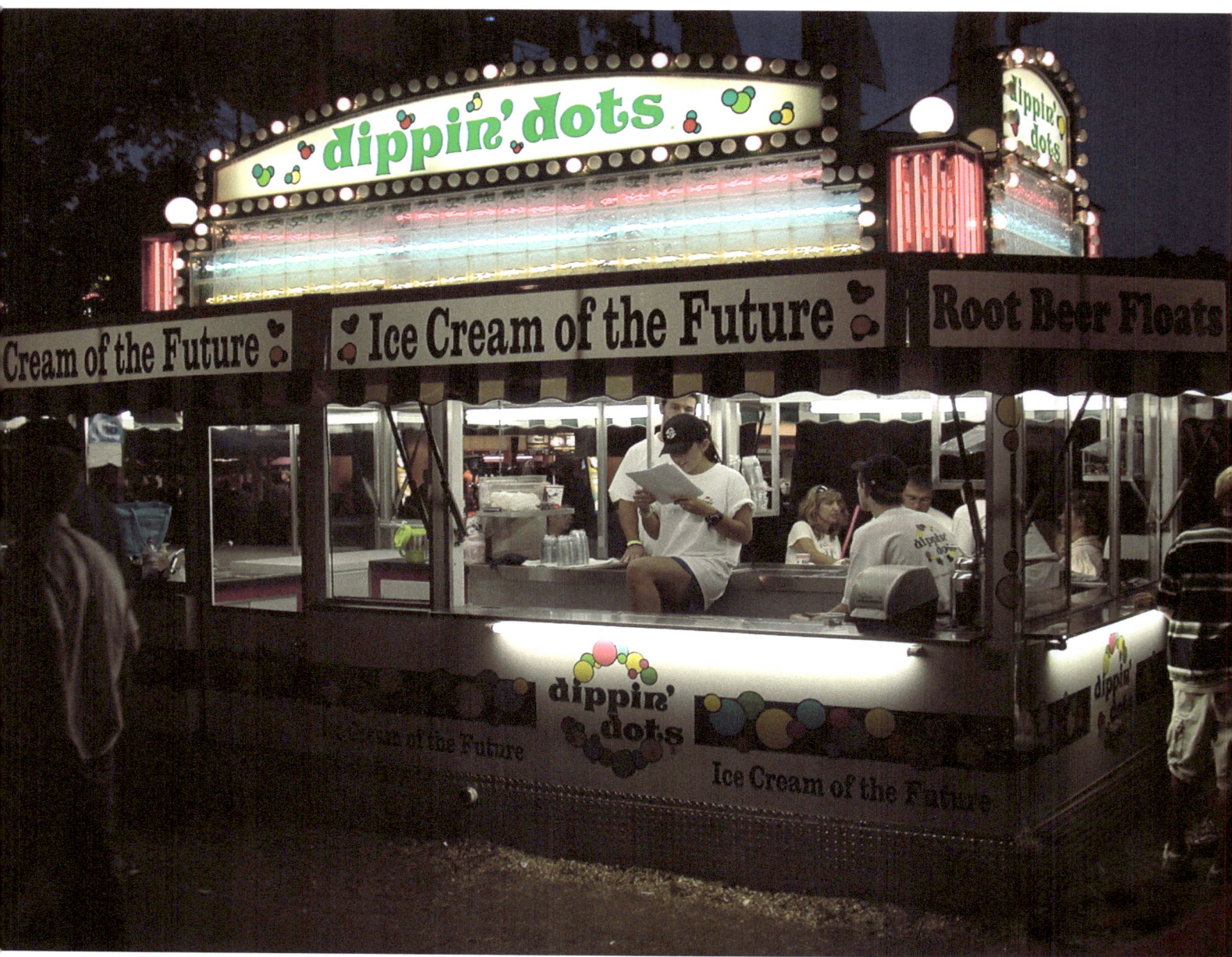

August 2006 – Minnesota State Fair, St Paul MN

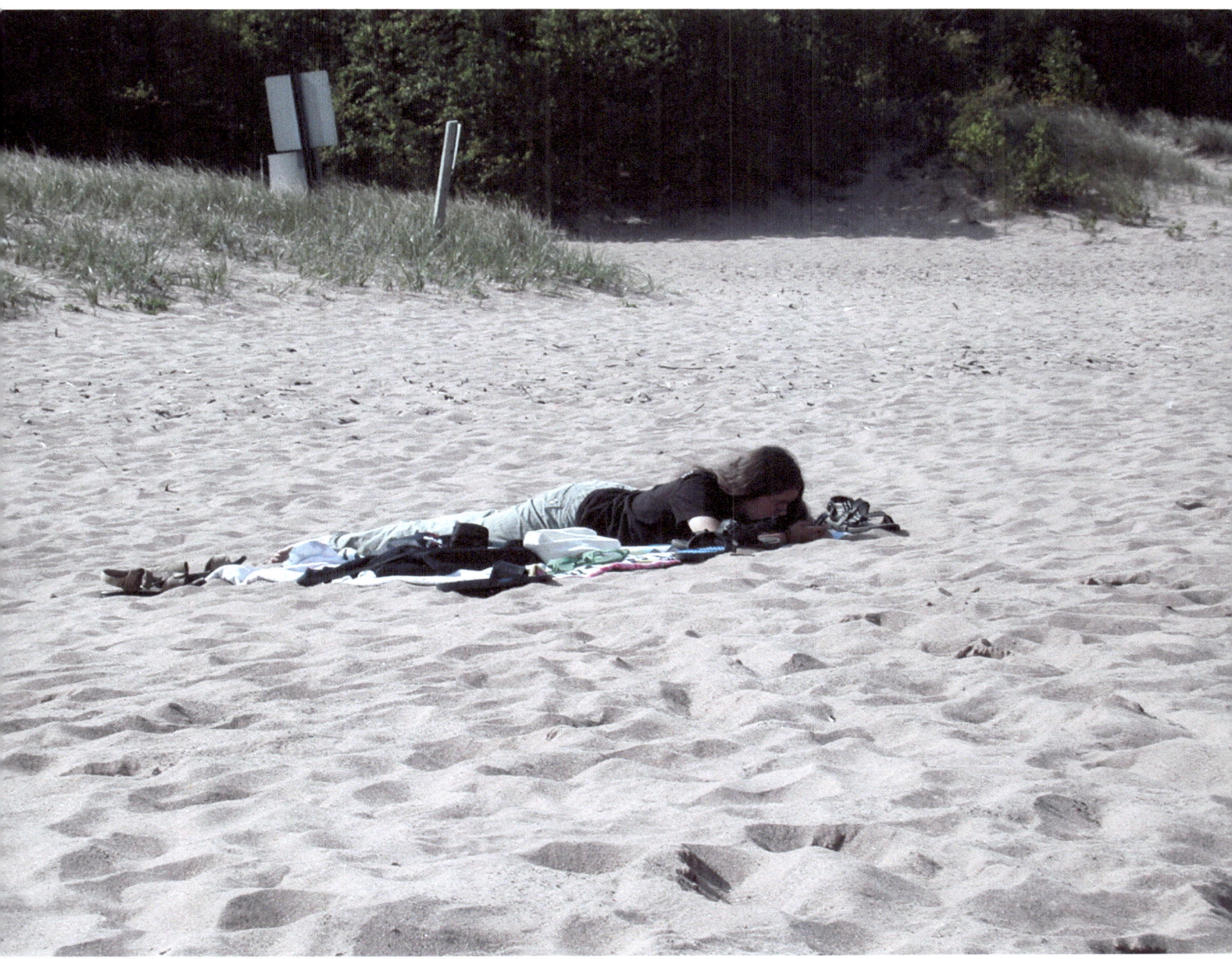

September 2006 – Park Point, Duluth MN

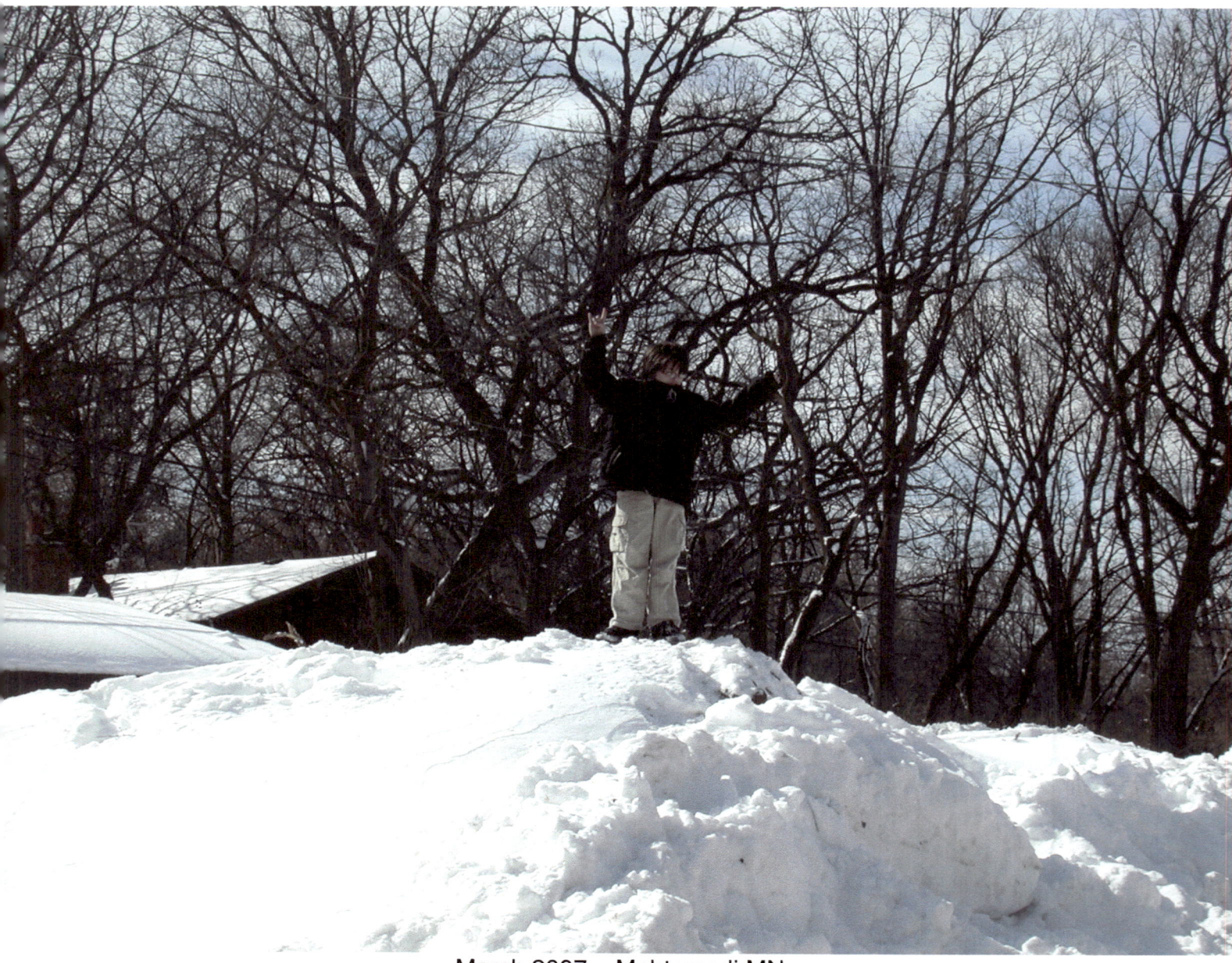
March 2007 – Mahtomedi MN

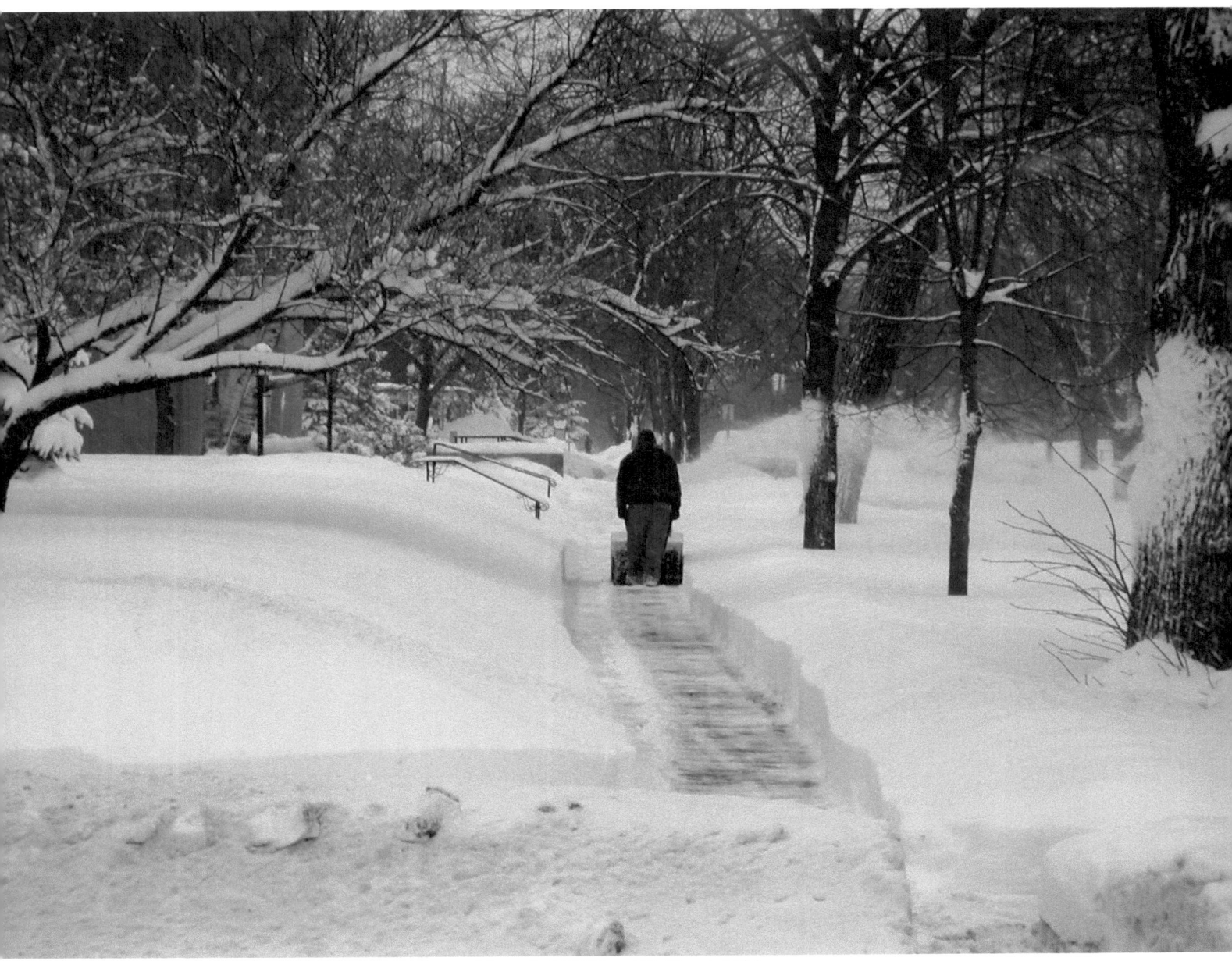
March 2007 – St Paul MN

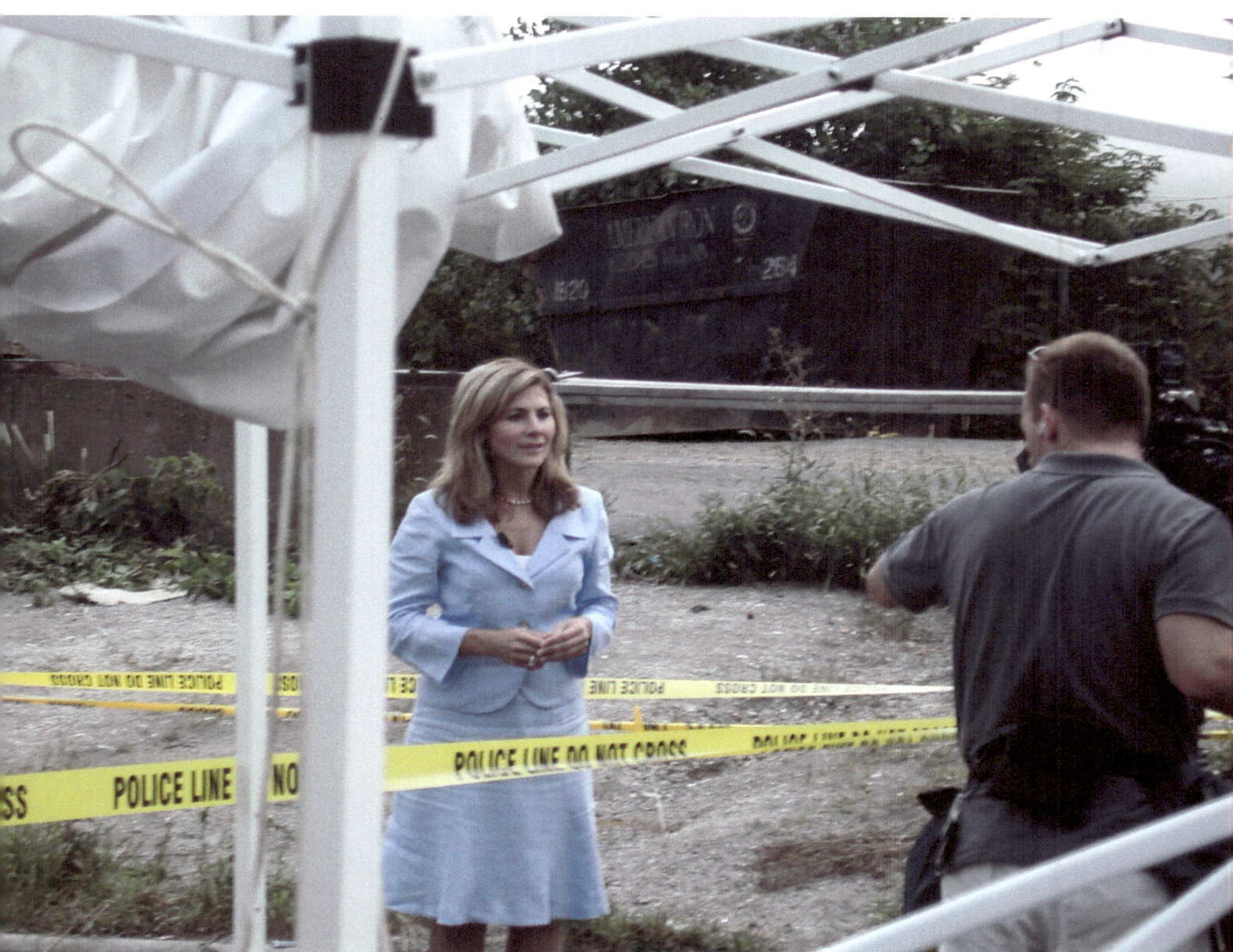

August 2007 – I-35W Bridge Collapse, Minneapolis MN

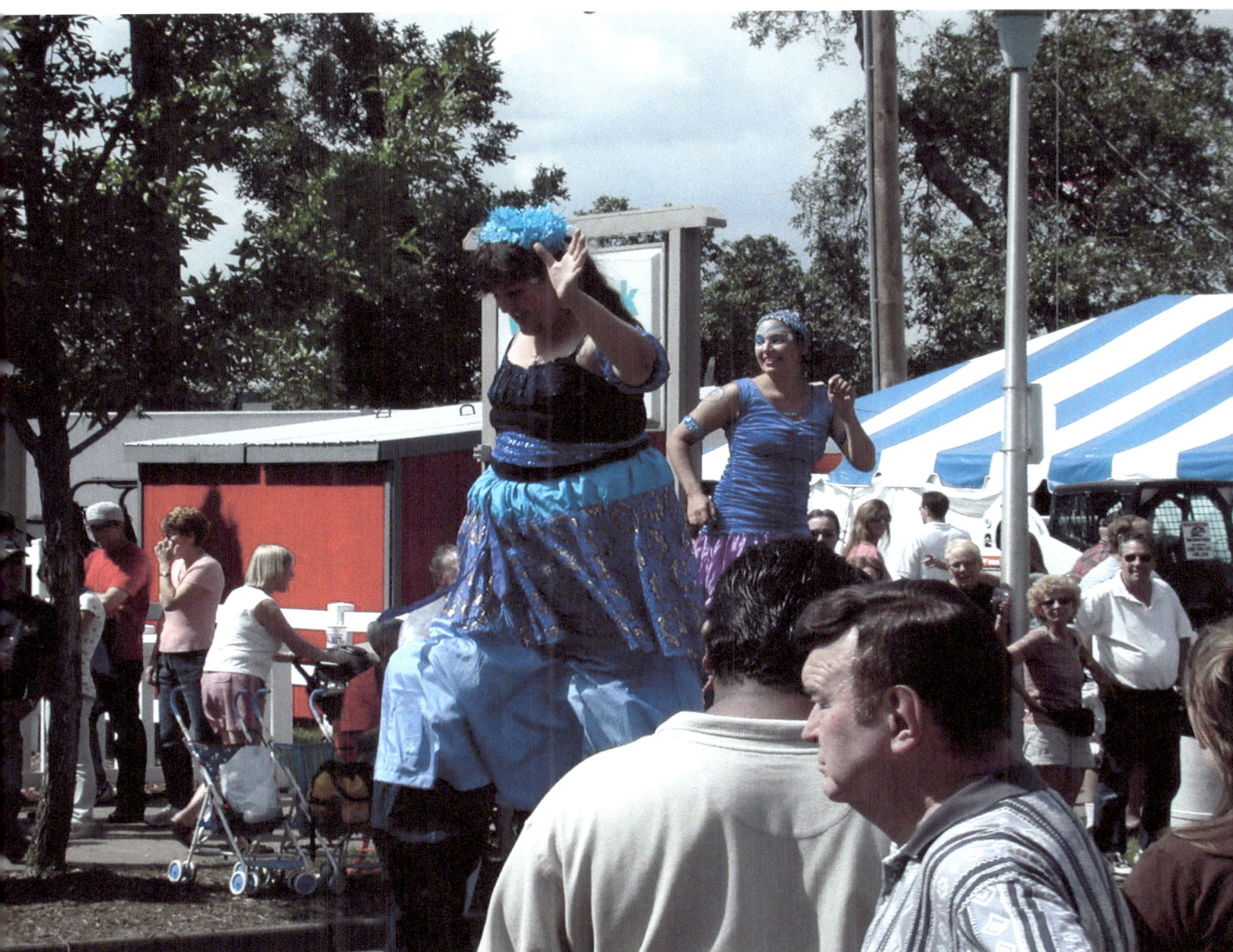

August 2007 – Minnesota State Fair, St Paul MN

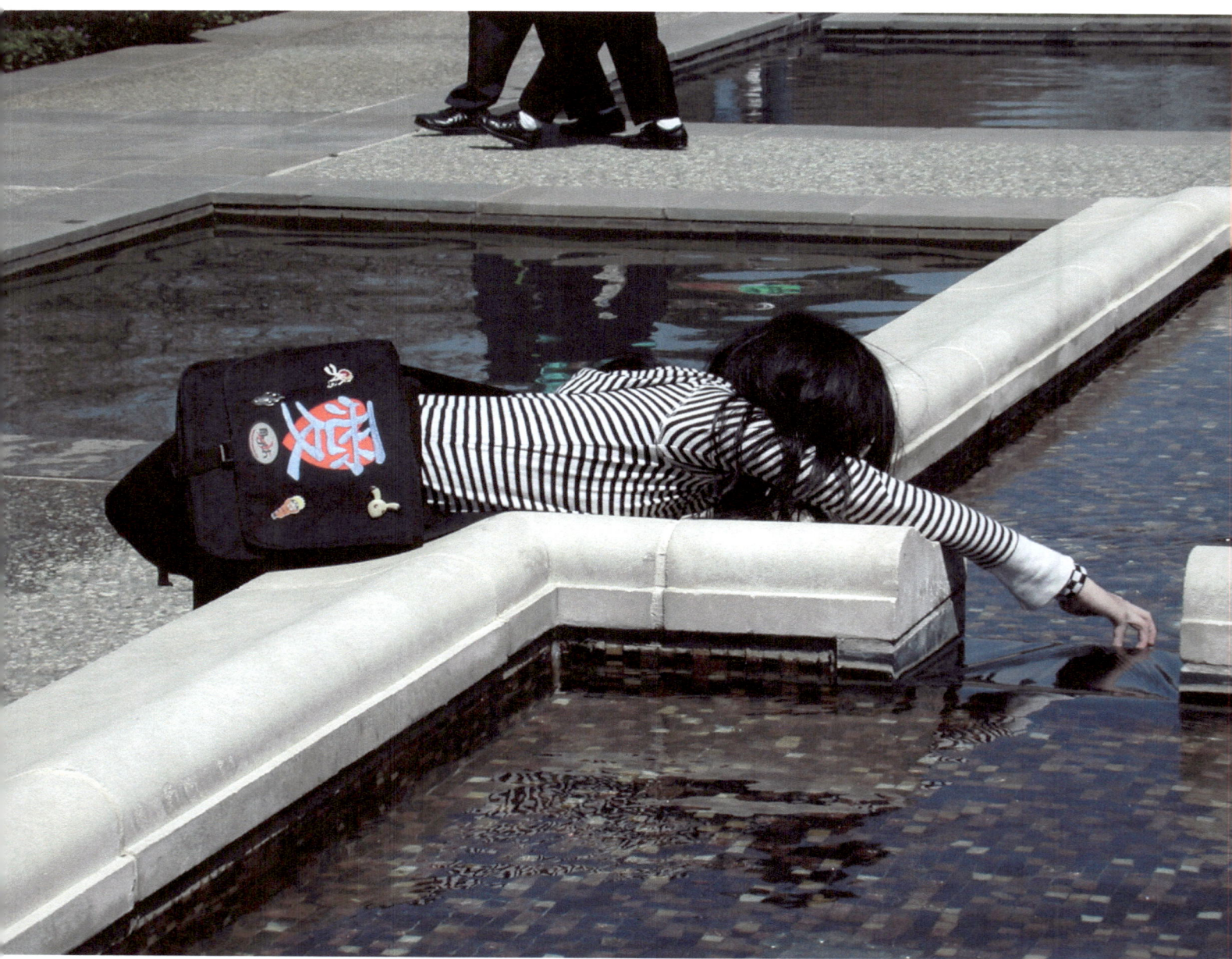

March 2007 – Dallas Arboretum, Dallas TX

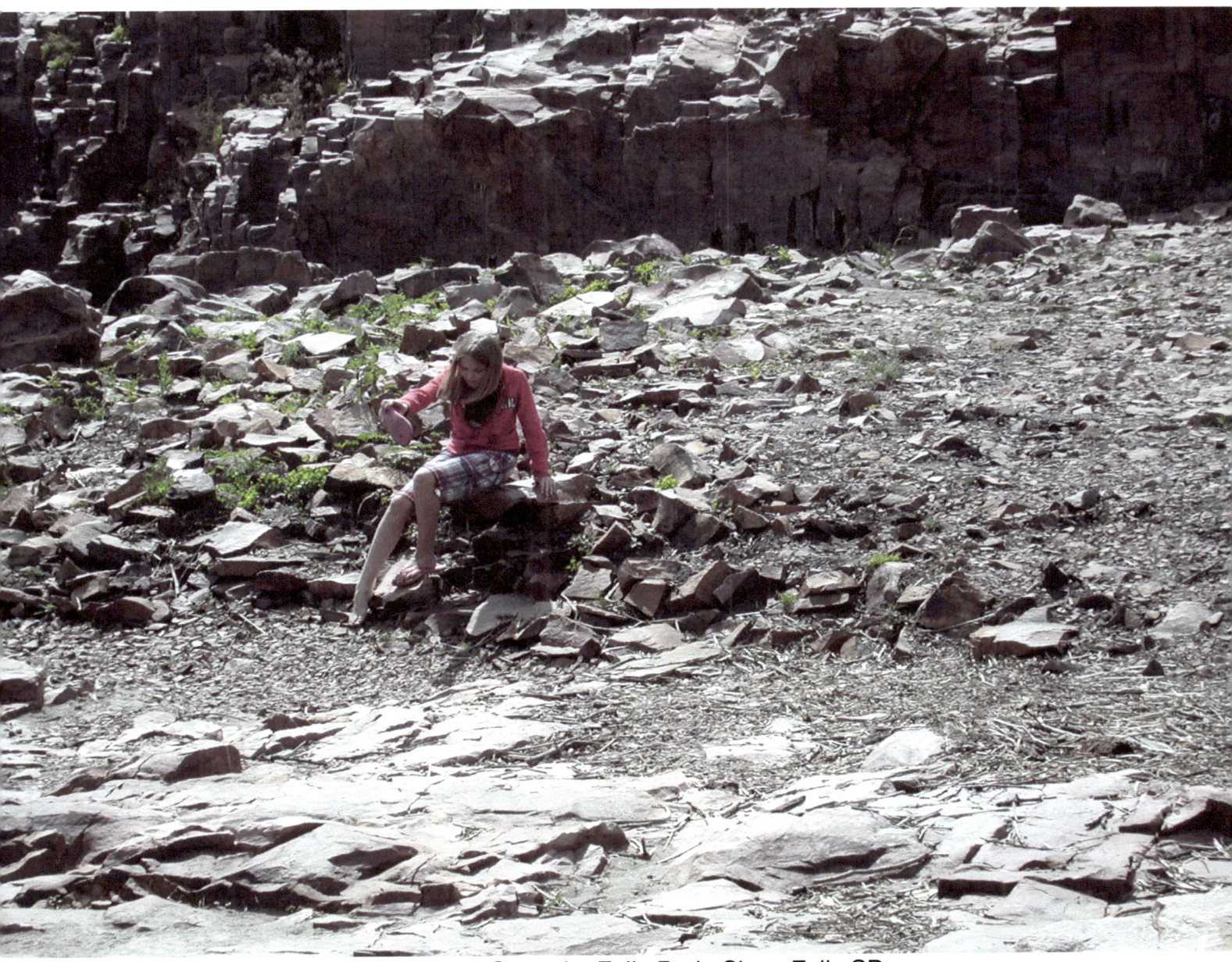
June 2008 – Quartzite Falls Park, Sioux Falls SD

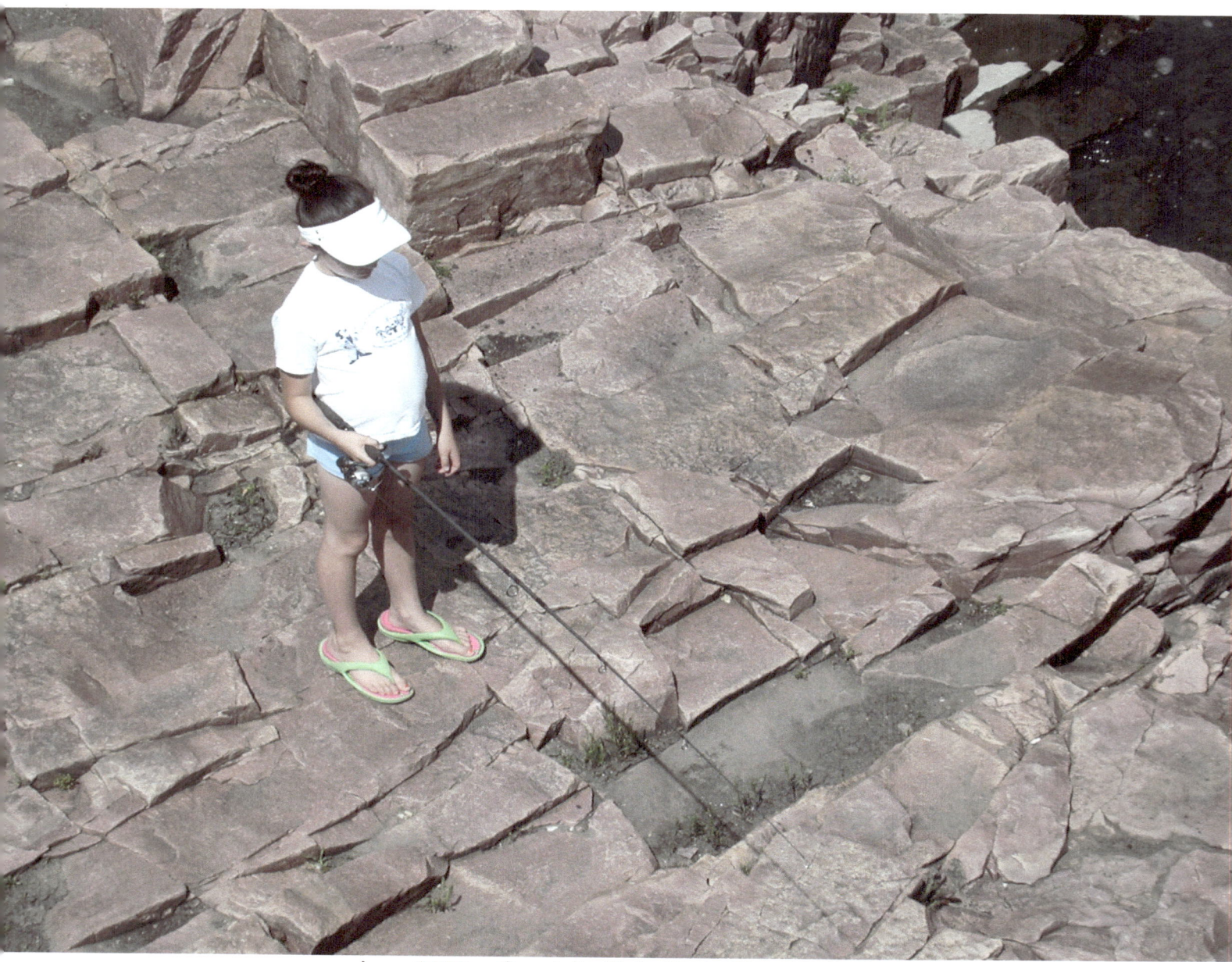

June 2008 – Quartzite Falls Park, Sioux Falls SD

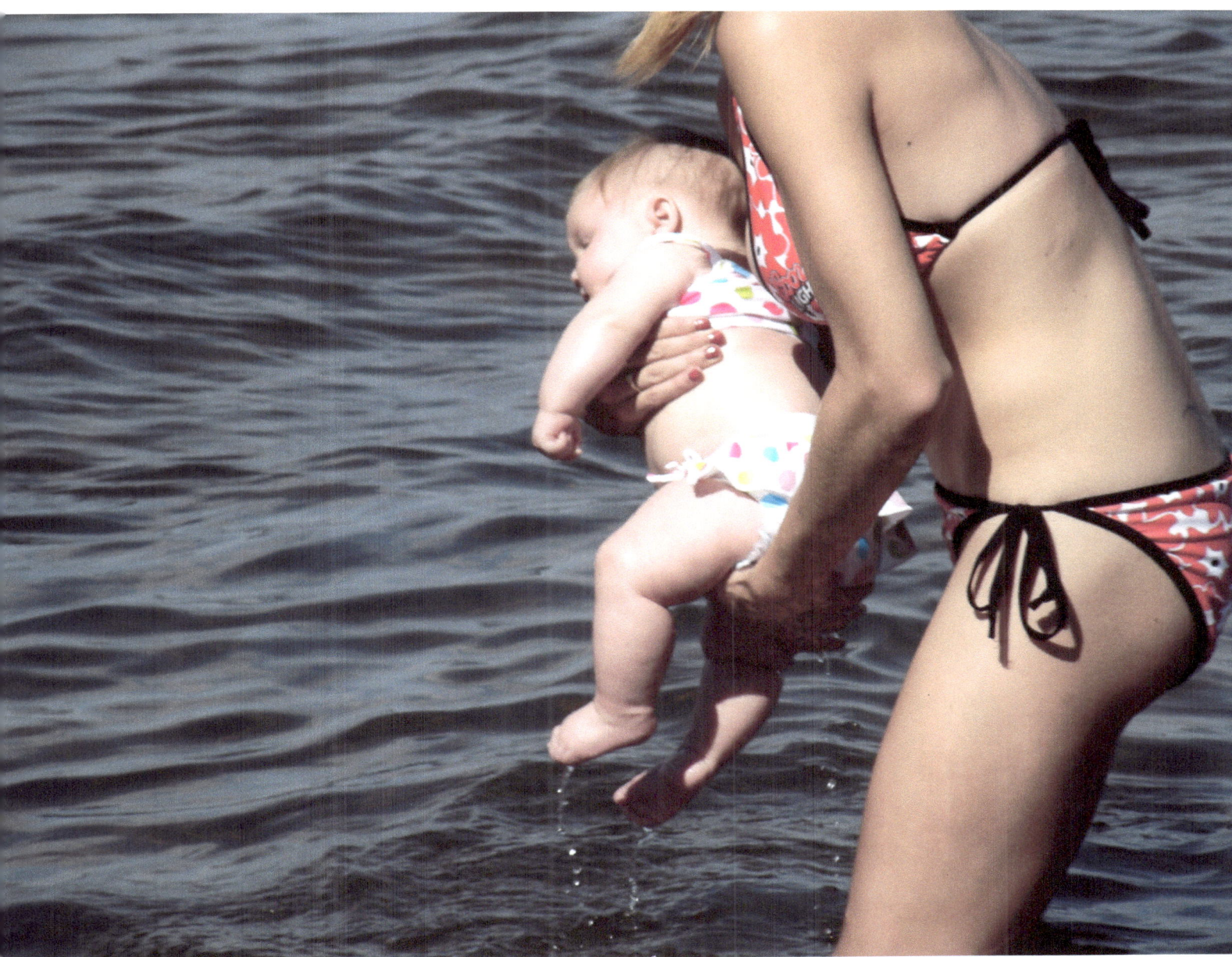
August 2008 – Park Point, Duluth MN

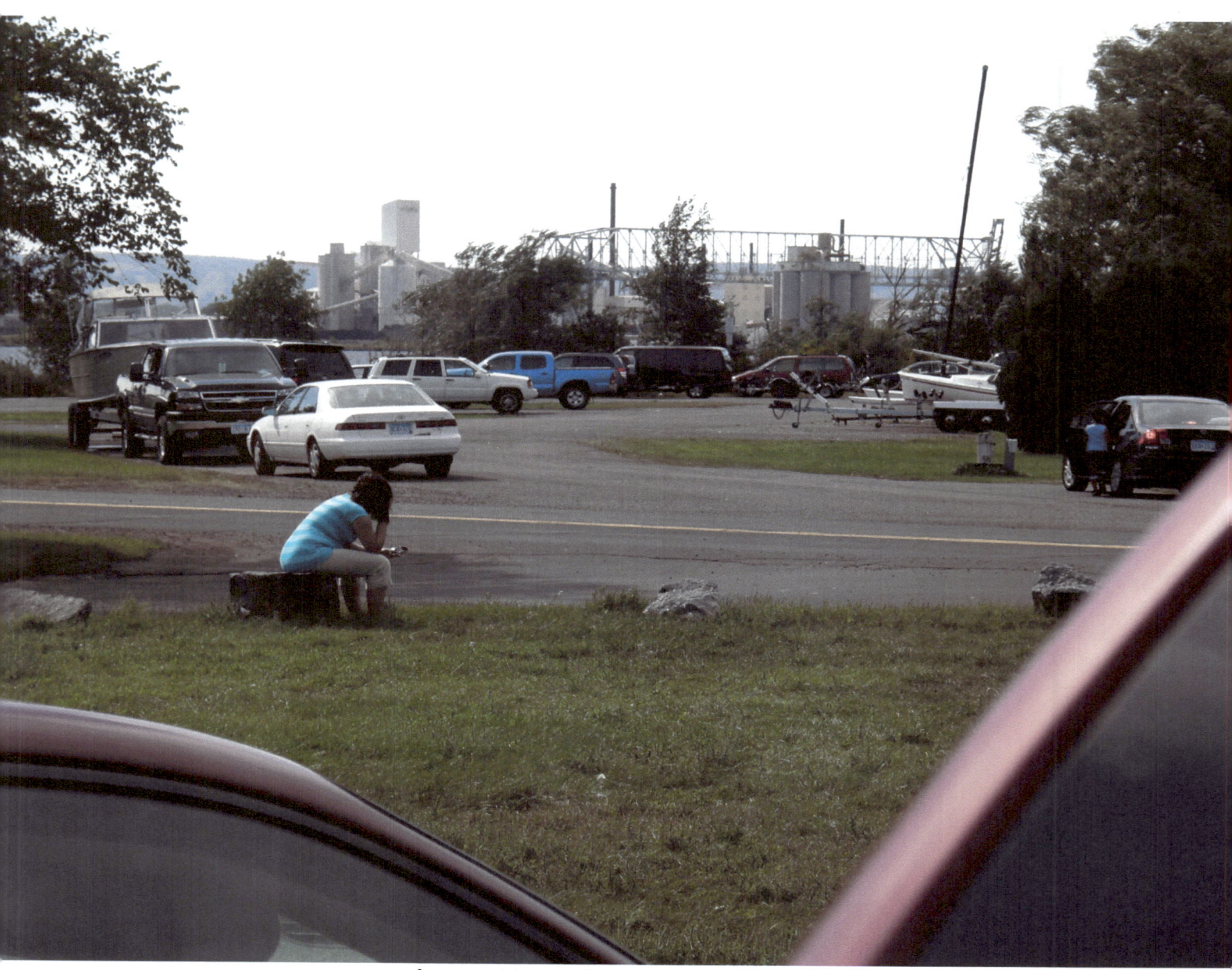

August 2008 – Park Point, Duluth MN

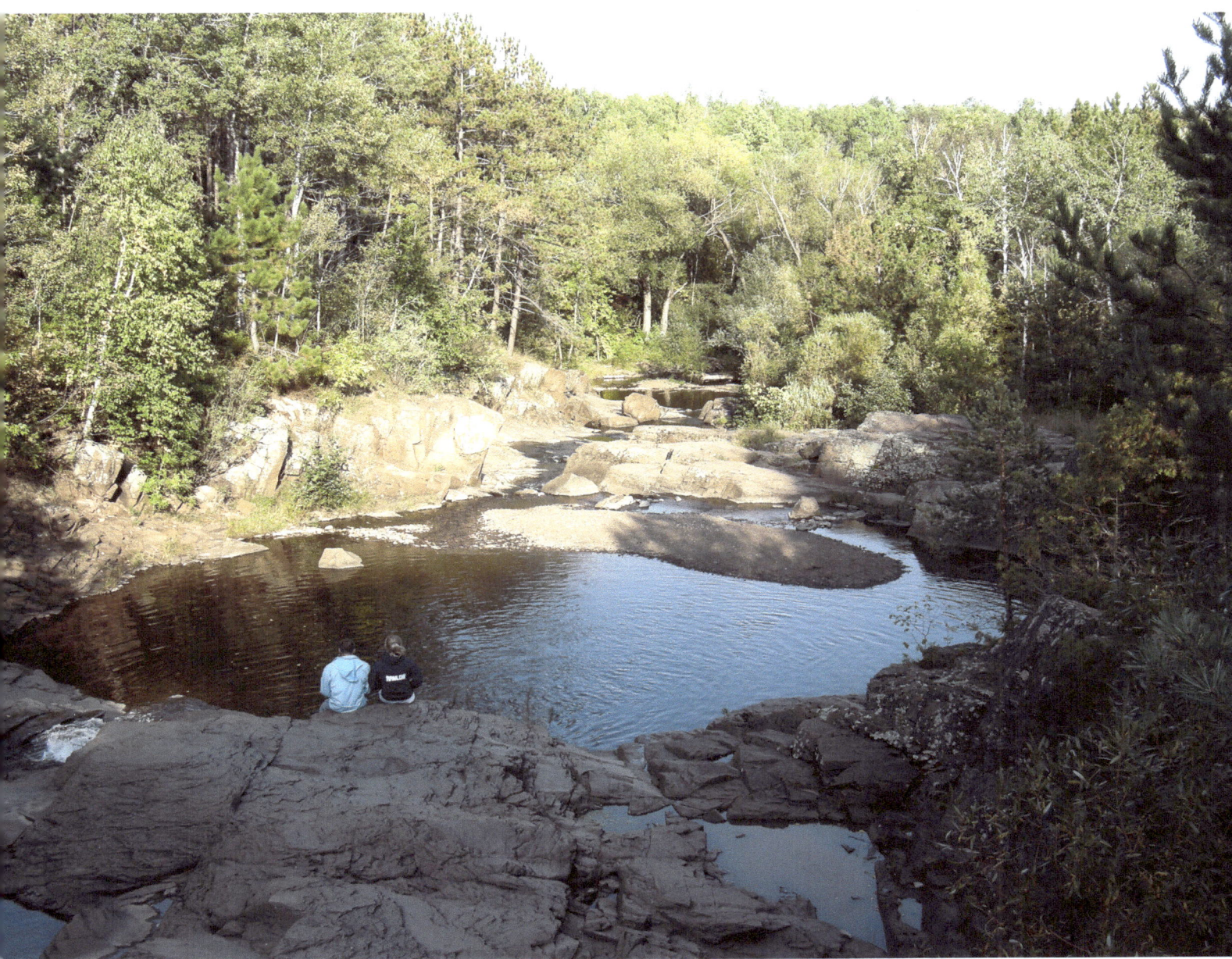

September 2008 – Seven Bridges Road, Duluth MN

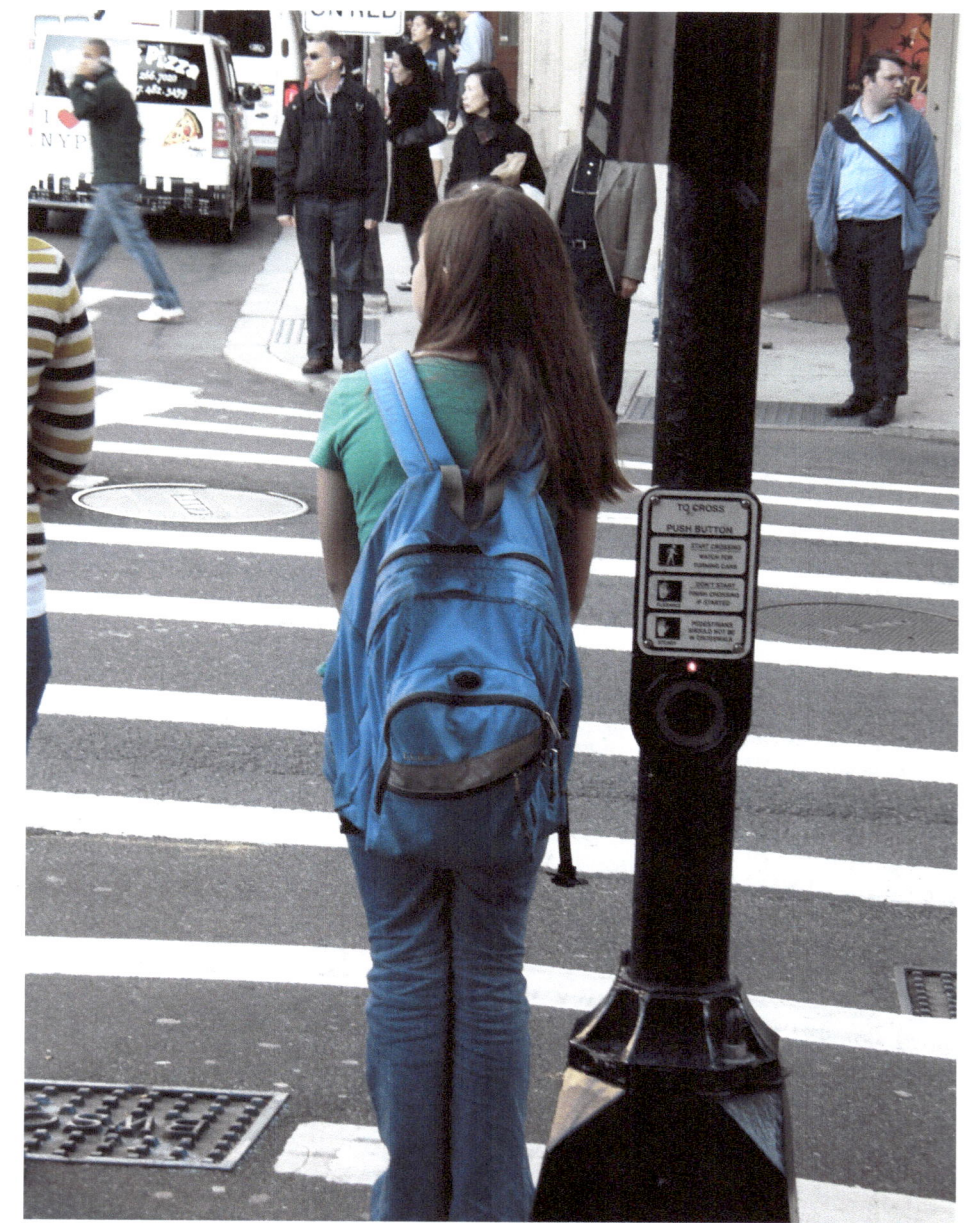

October 2008 – Boston MA

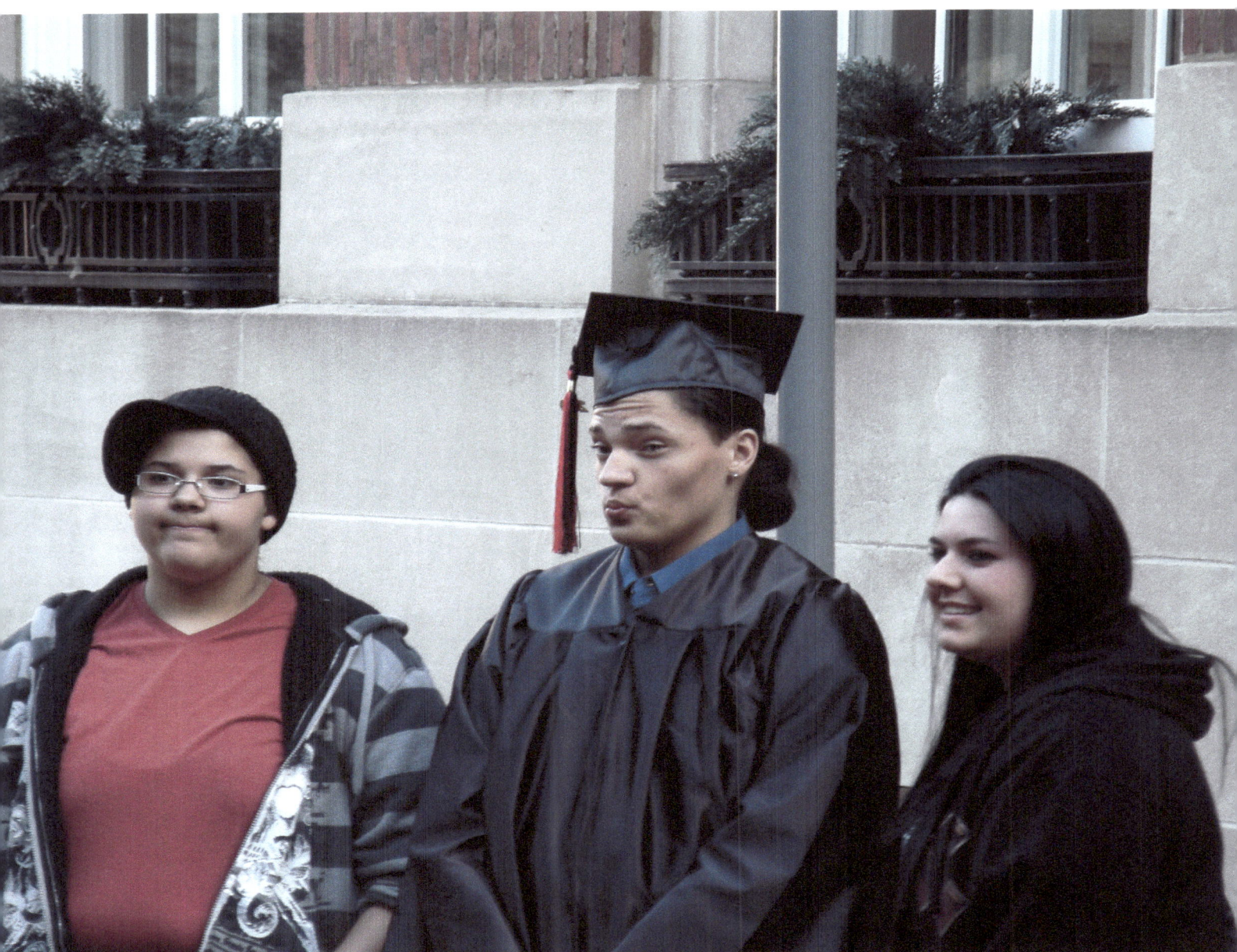
June 2010 – St Paul MN

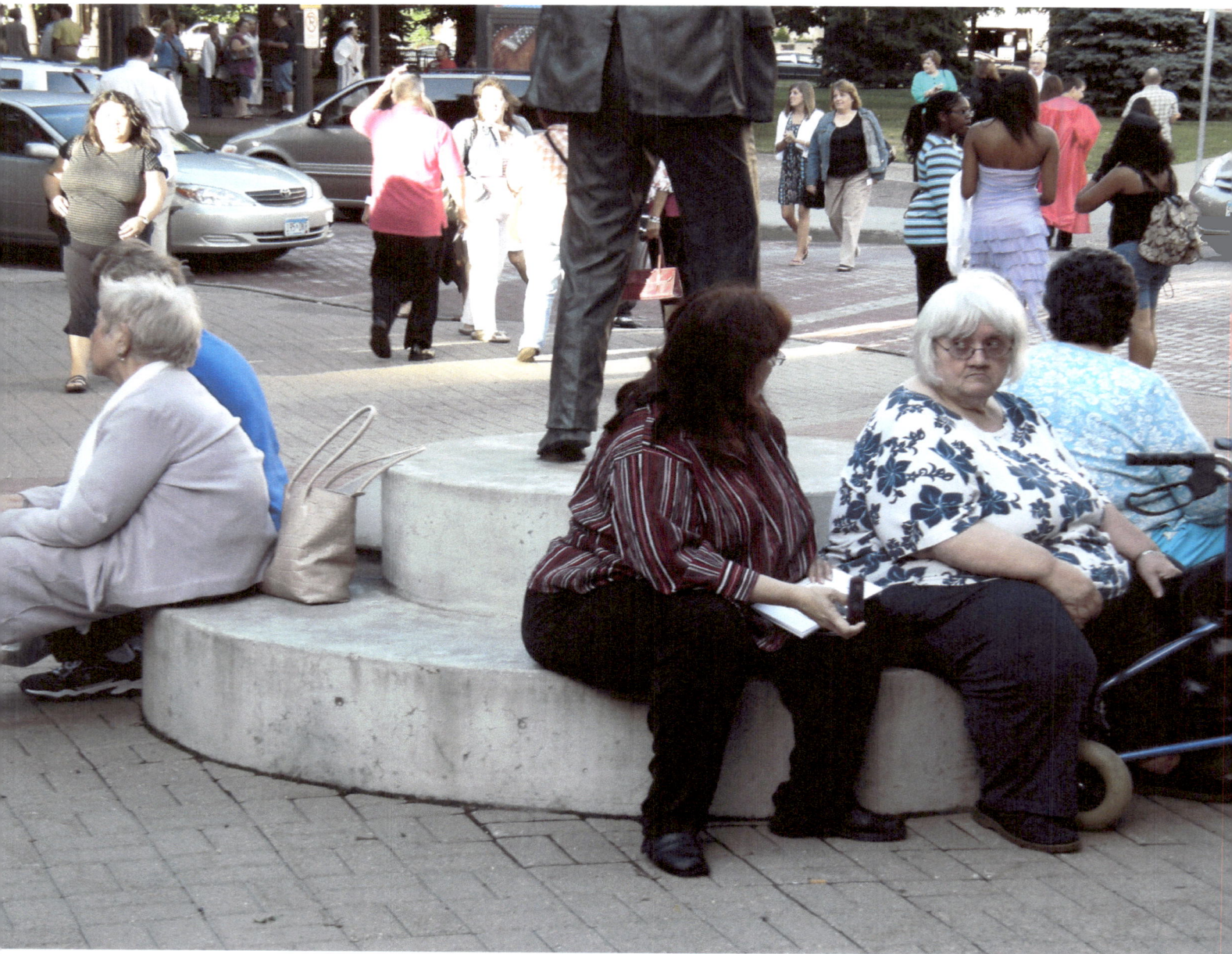
June 2010 – St Paul MN

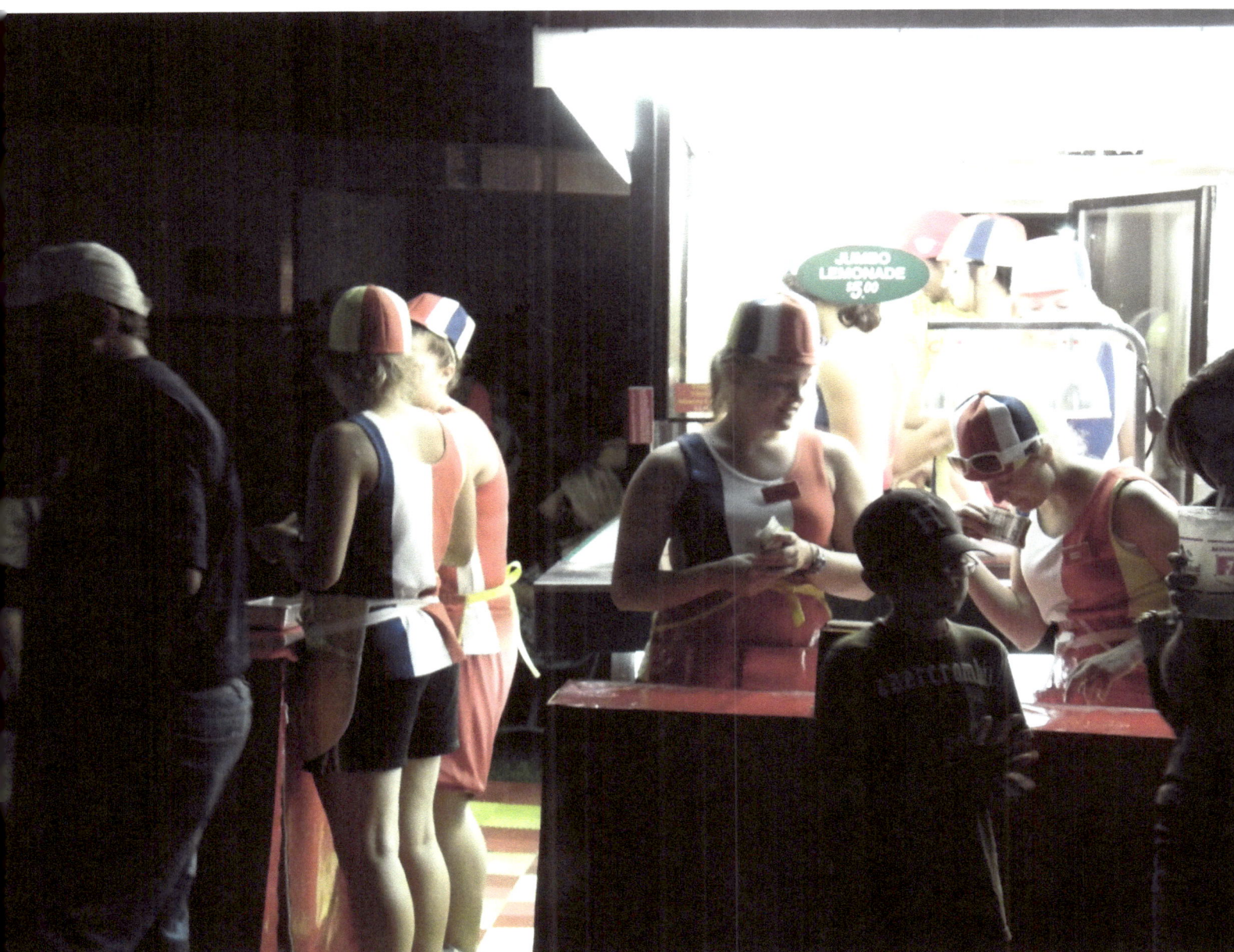
August 2010 – Minnesota State Fair, St Paul MN

August 2010 – Minnesota State Fair, St Paul MN

August 2010 – Minnesota State Fair, St Paul MN

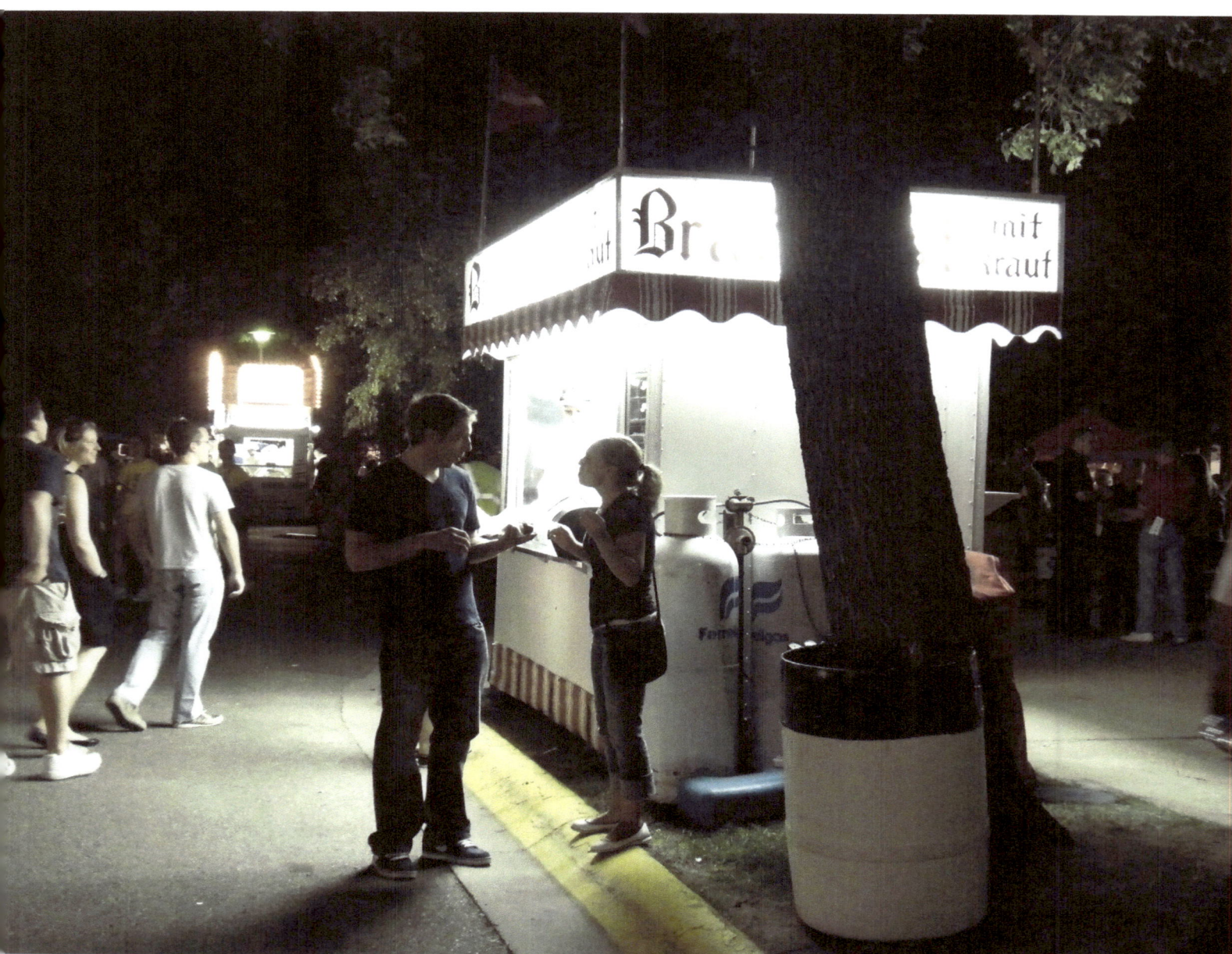

August 2010 – Minnesota State Fair, St Paul MN

August 2010 – Minnesota State Fair, St Paul MN

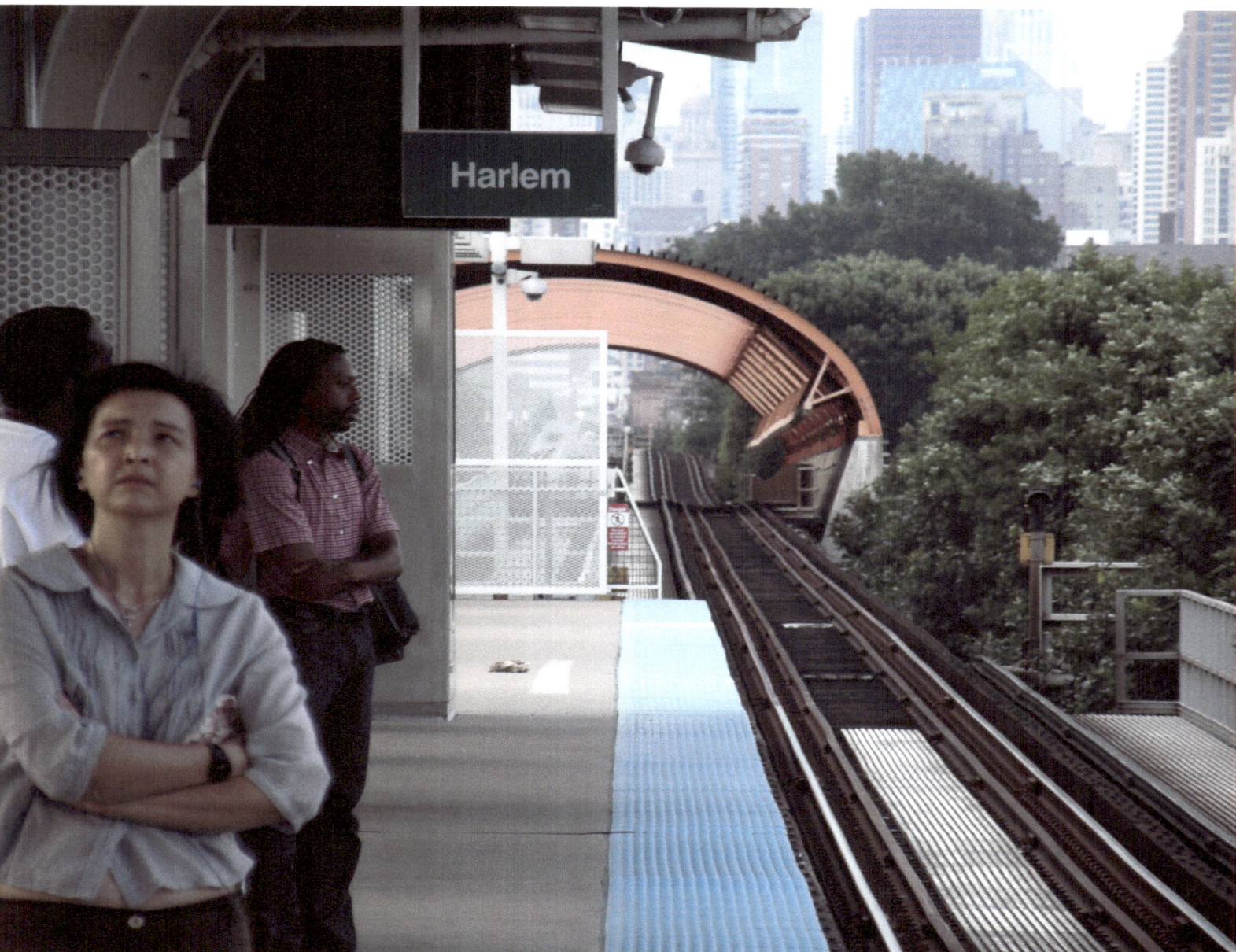

August 2011 – Illinois Institute of Technology, Chicago IL (yes, the sign does say "Harlem"...)

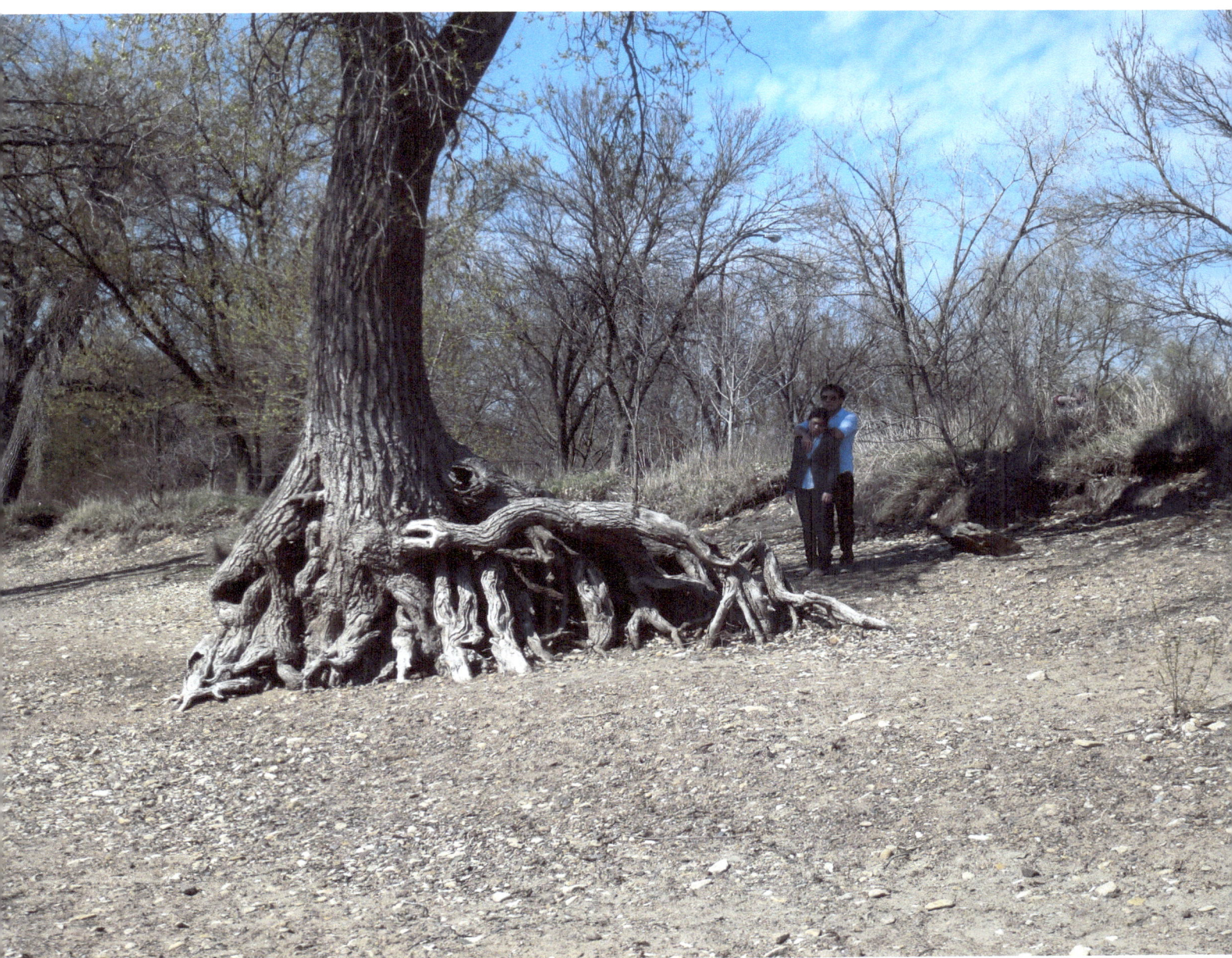

April 2012 – banks of the Mississippi River, St Paul MN

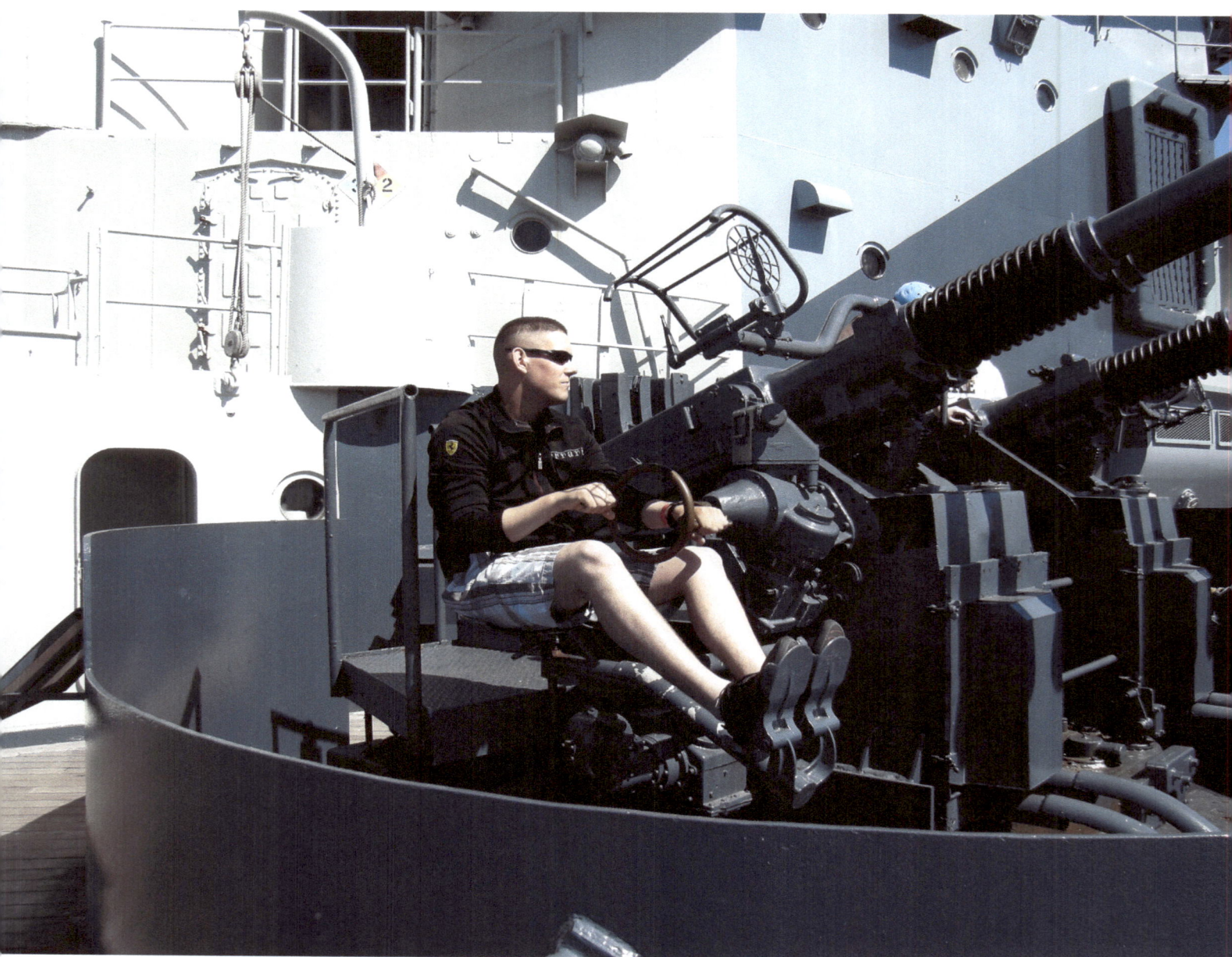

April 2012 – Battleship *North Carolina*, Wilmington, NC

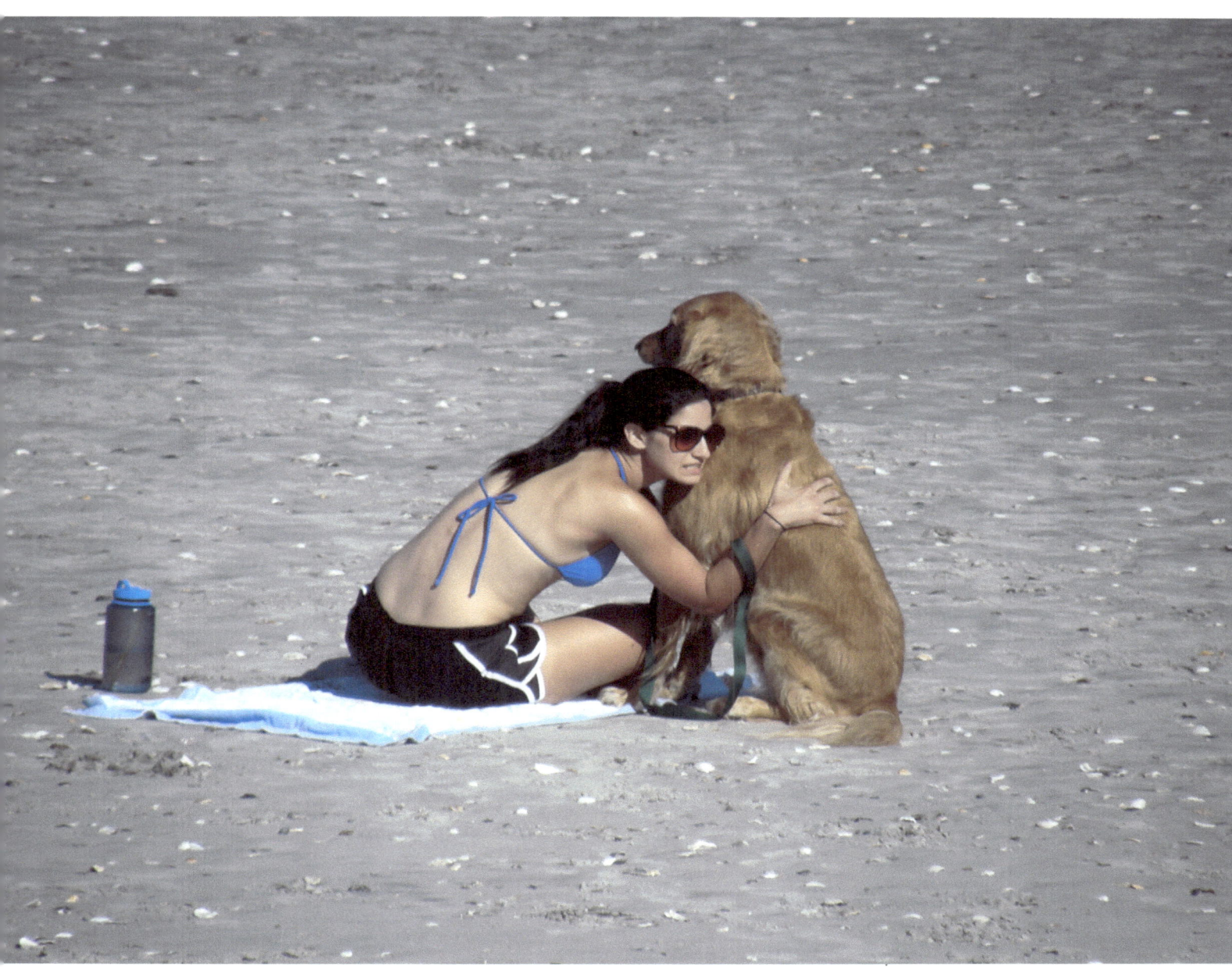

April 2012 – Topsail Beach, Ashe Island NC

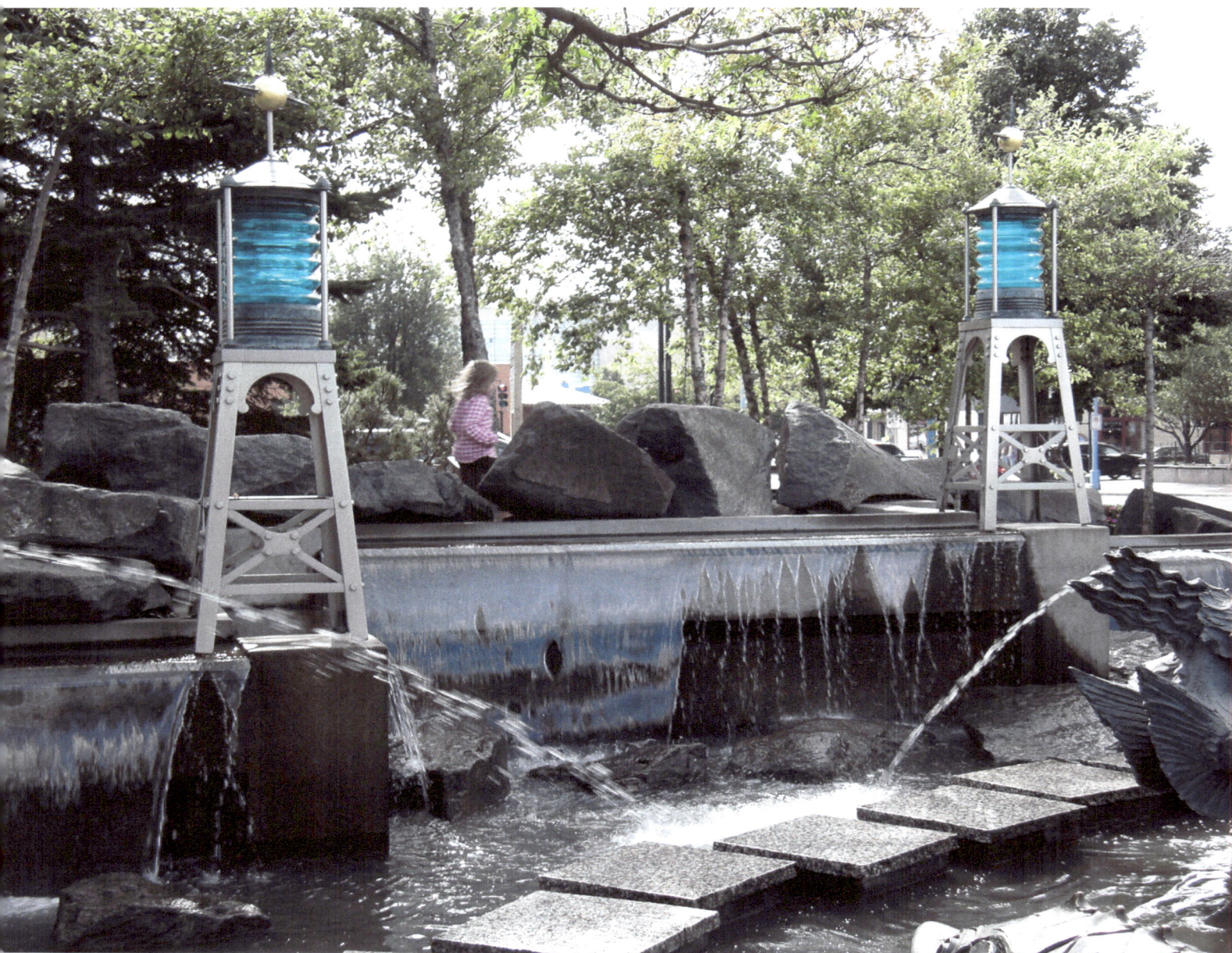
August 2012 – Canal Park, Duluth MN

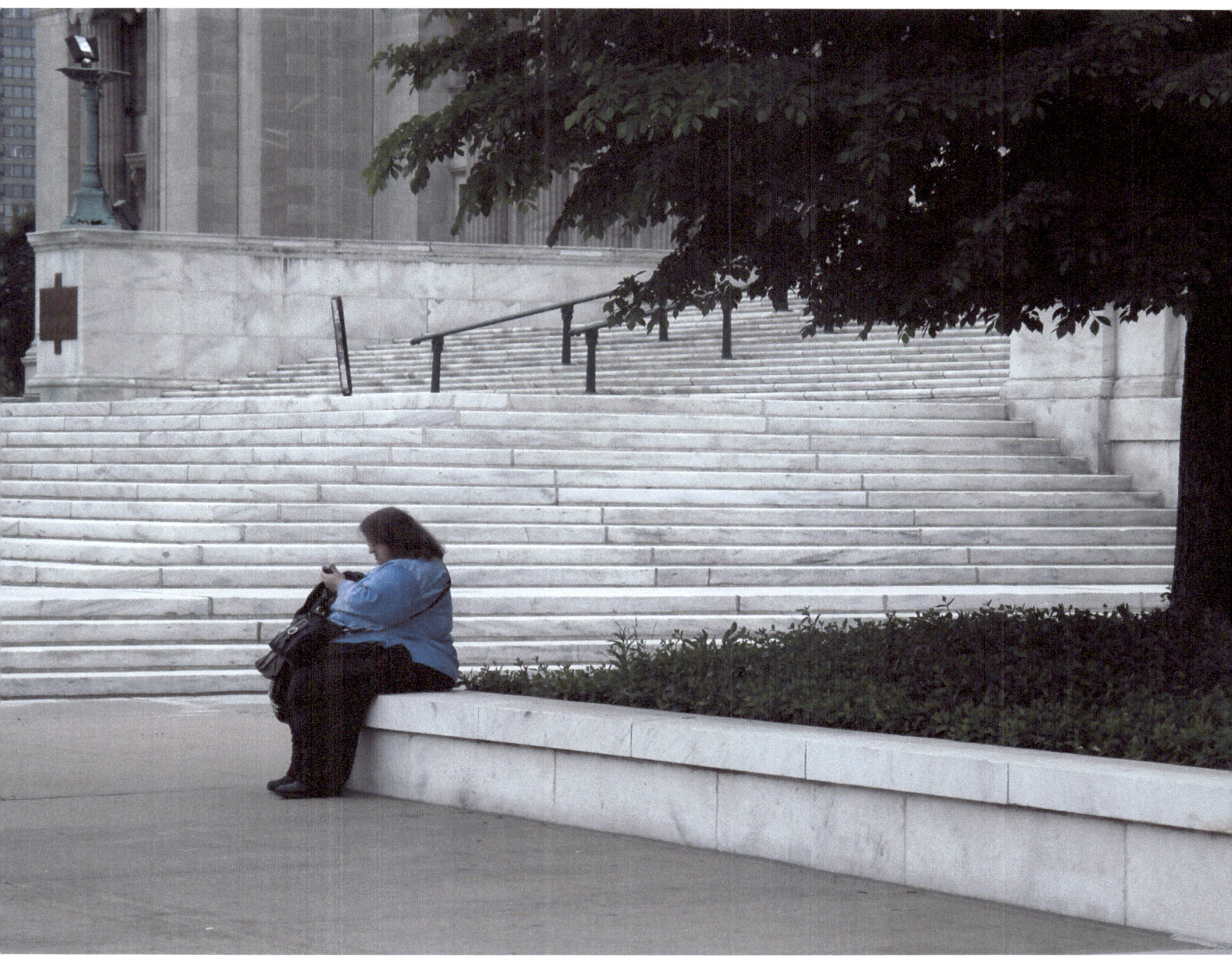

May 2013 – Field Museum, Chicago IL

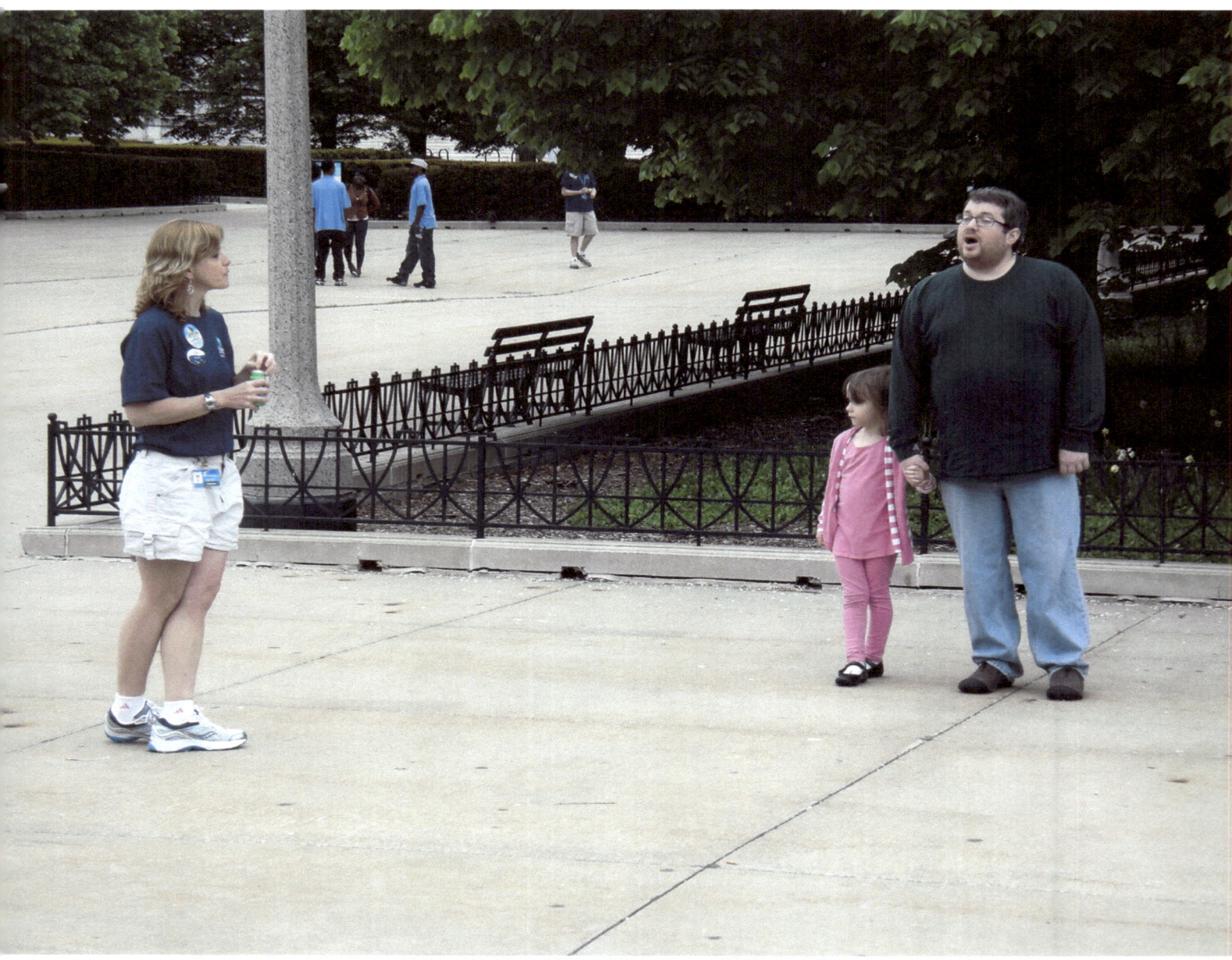

May 2013 – Field Museum, Chicago IL

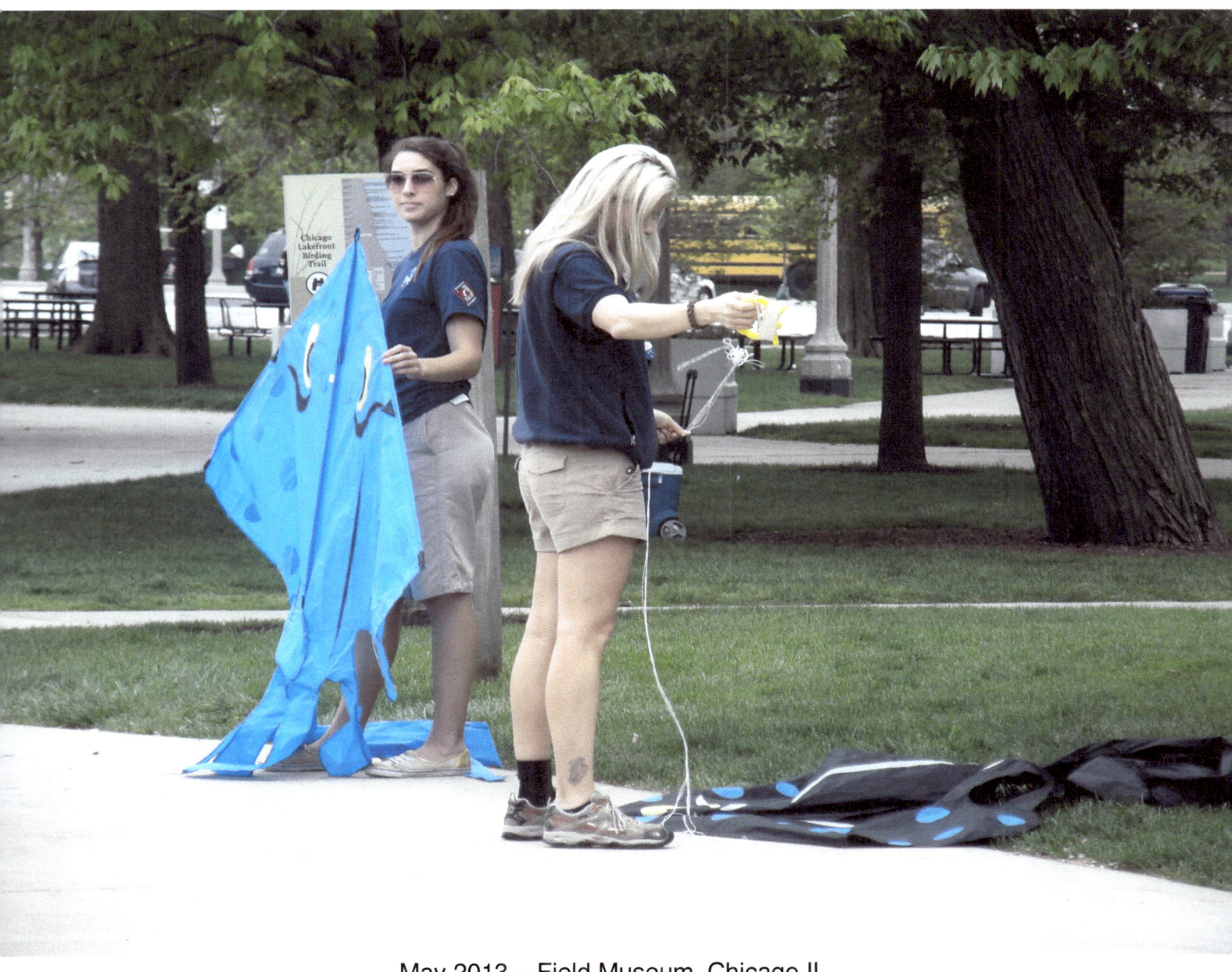

May 2013 – Field Museum, Chicago IL

May 2013 – Illinois Institute of Technology, Chicago IL

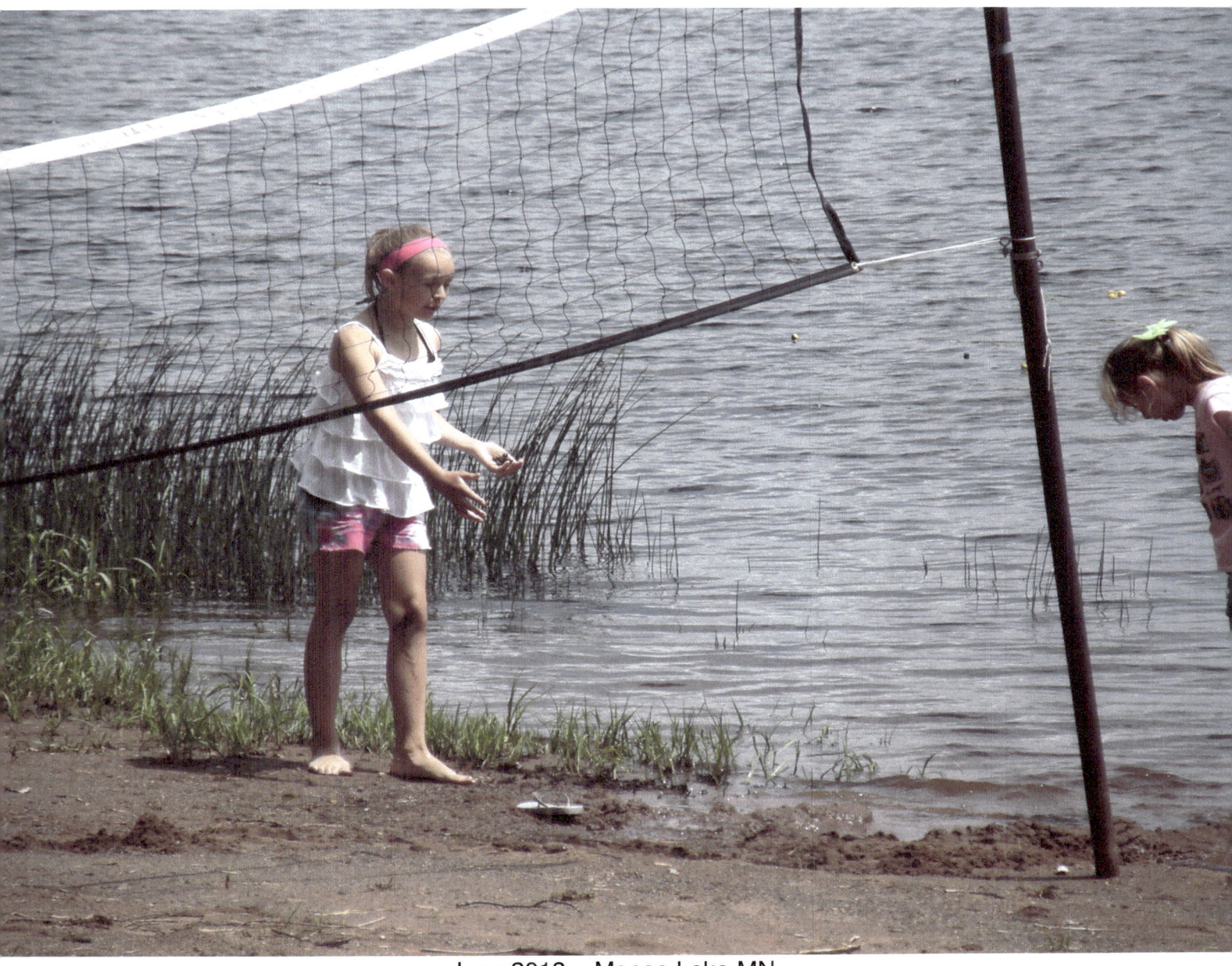
June 2013 – Moose Lake MN

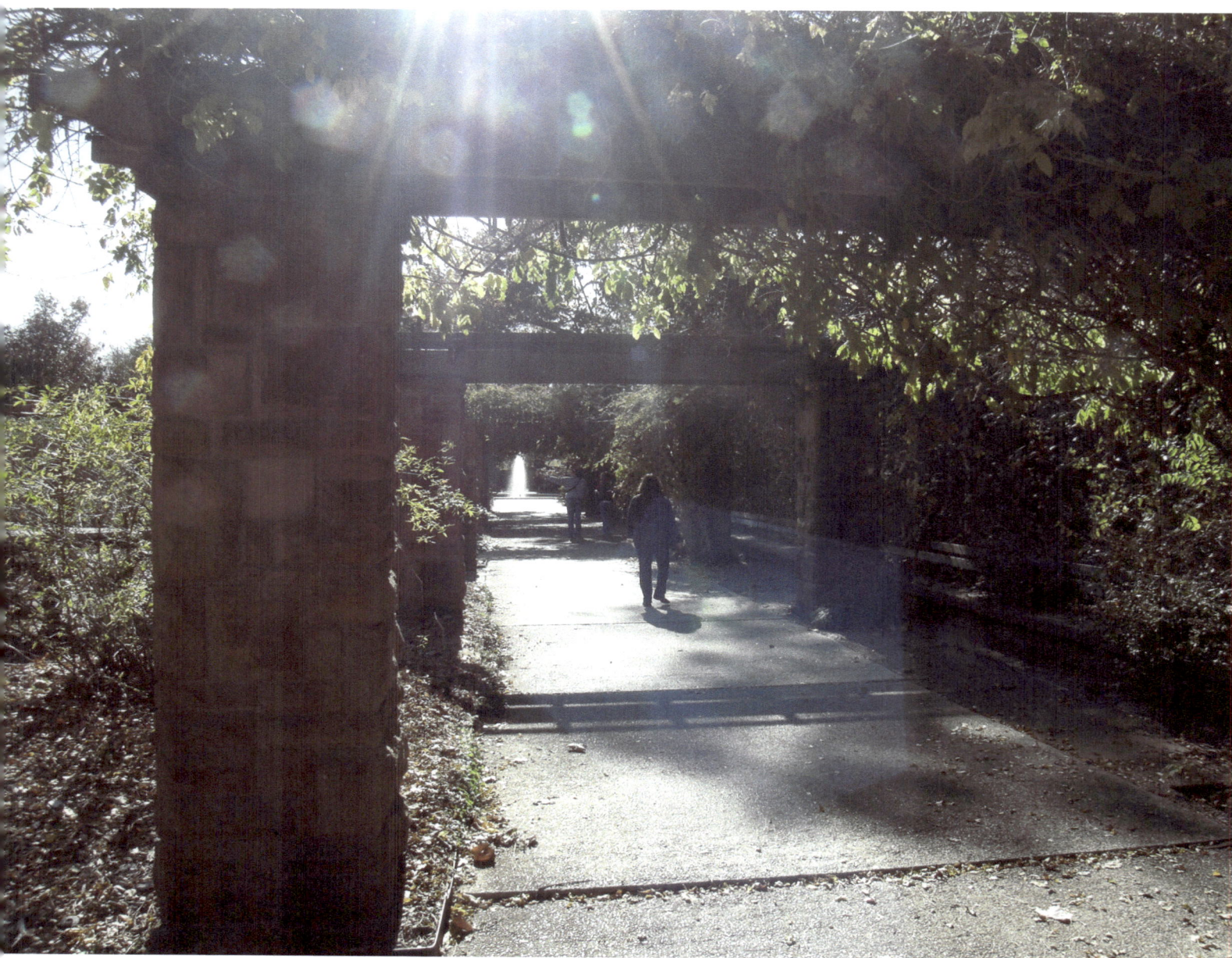
November 2013 – Fort Worth Botanical Garden, Fort Worth TX

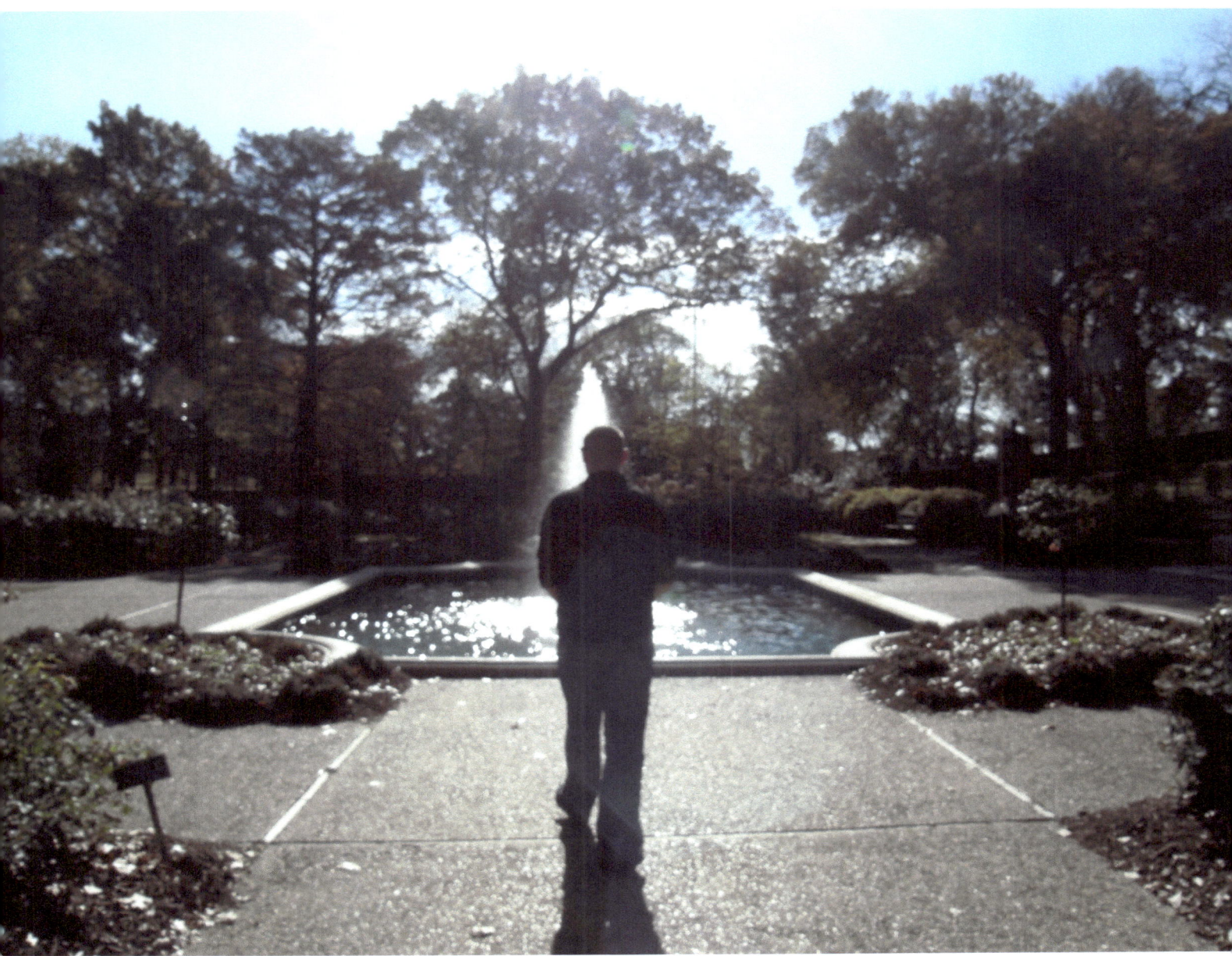

November 2013 – Fort Worth Botanical Garden, Fort Worth TX

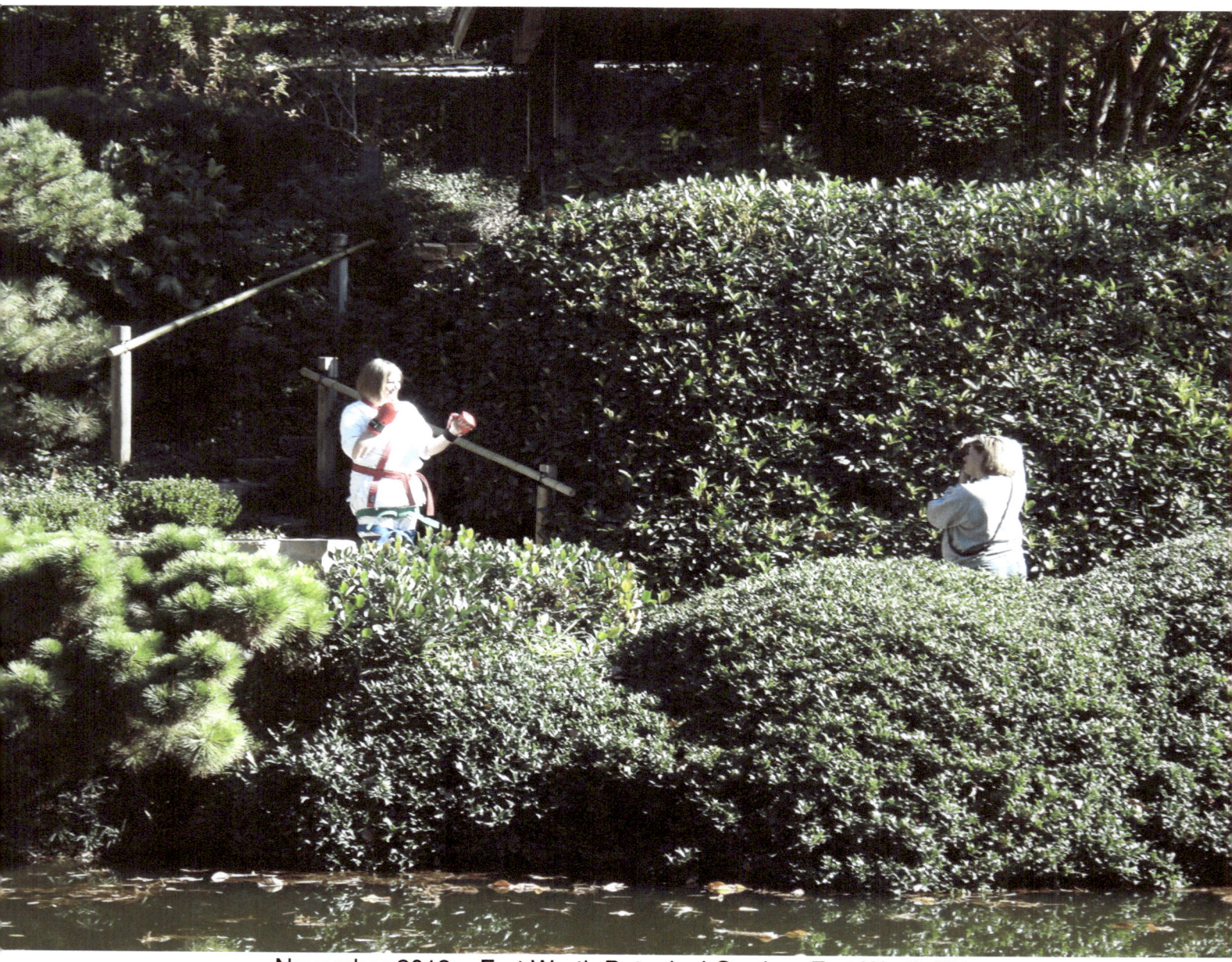

November 2013 – Fort Worth Botanical Garden, Fort Worth TX

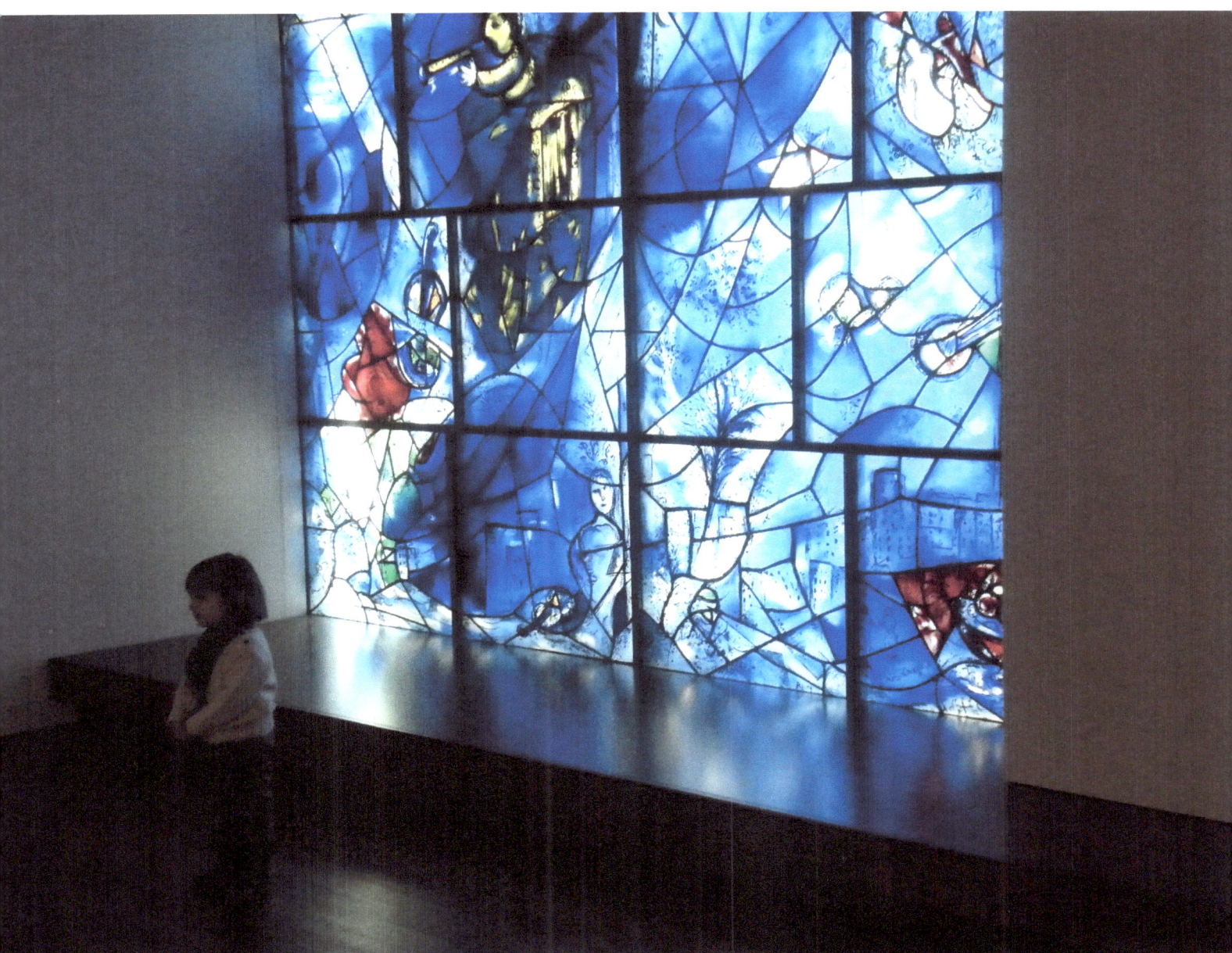

December 2013 – Art Institute of Chicago, Chicago IL

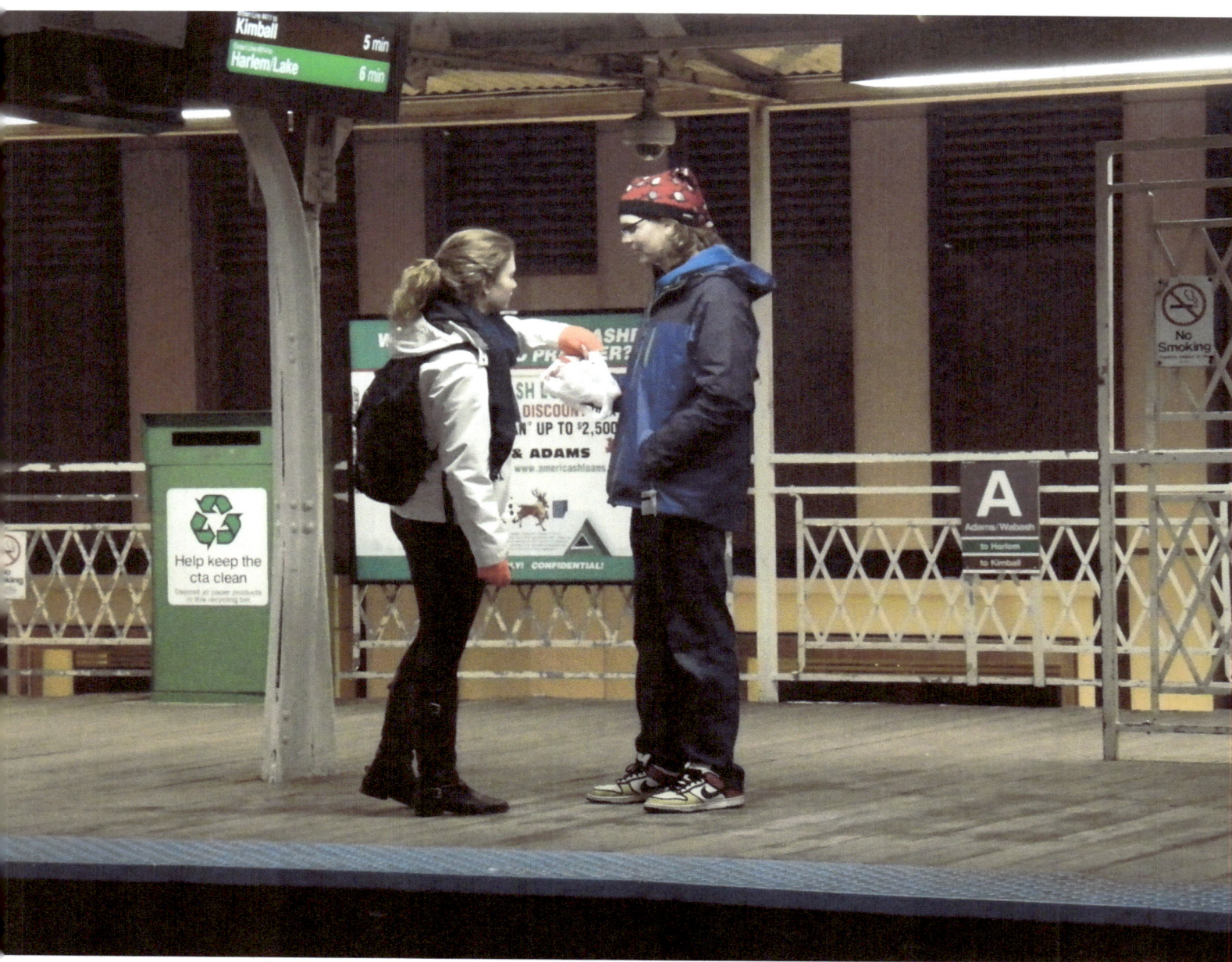

December 2013 – Chicago IL

December 2013 – Chicago IL

December 2013 – Chicago IL

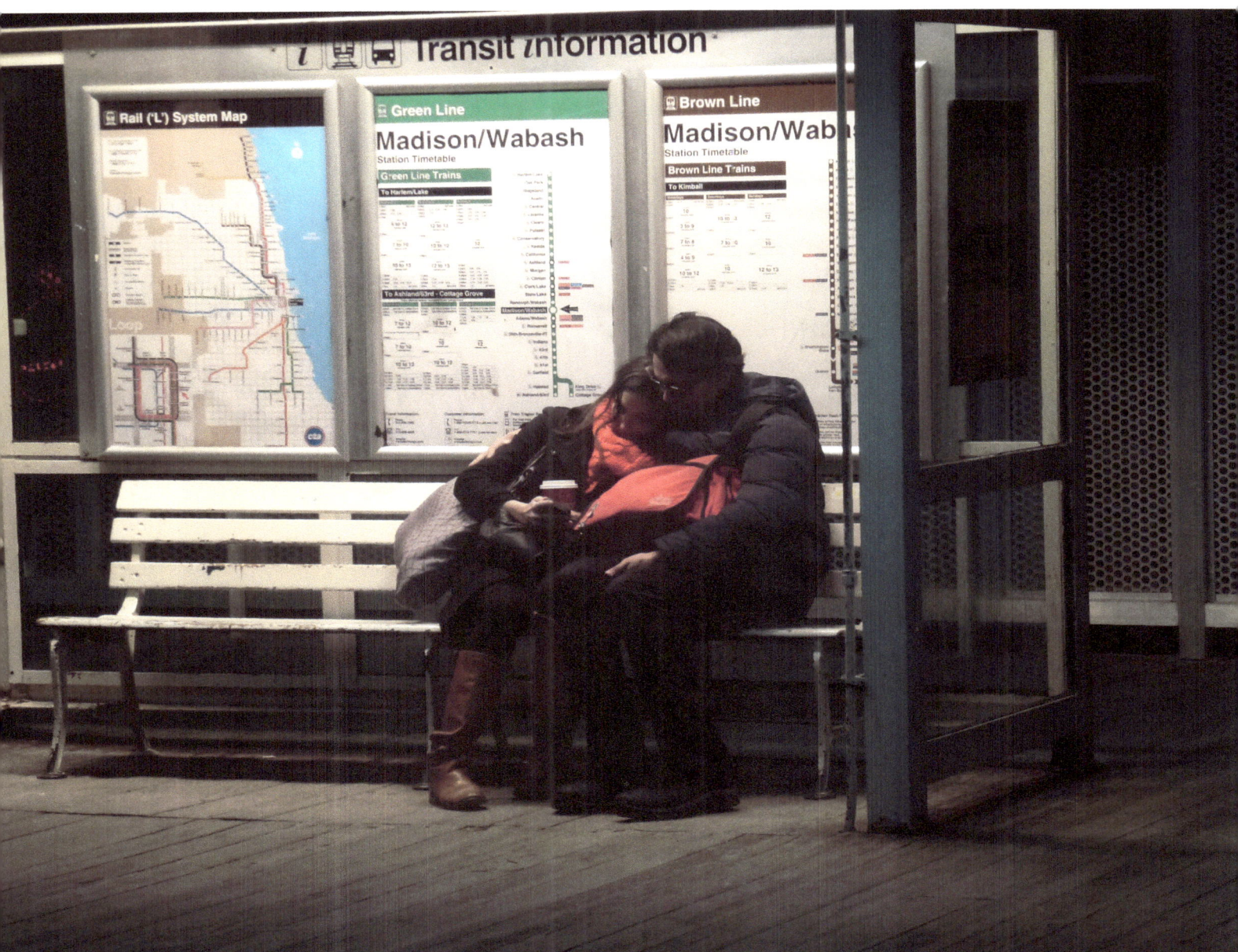

December 2013 – Chicago IL

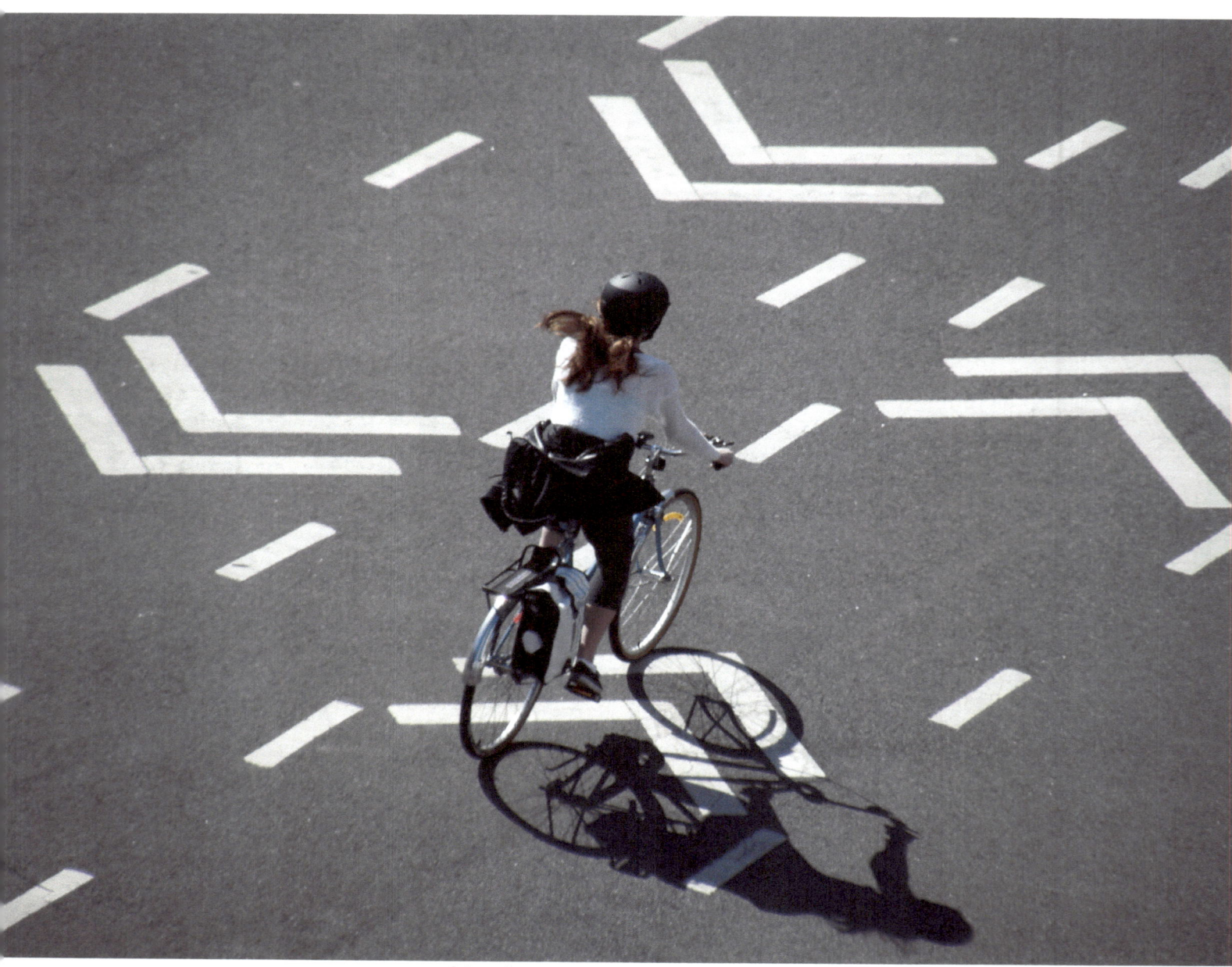
March 2014 – Washington DC

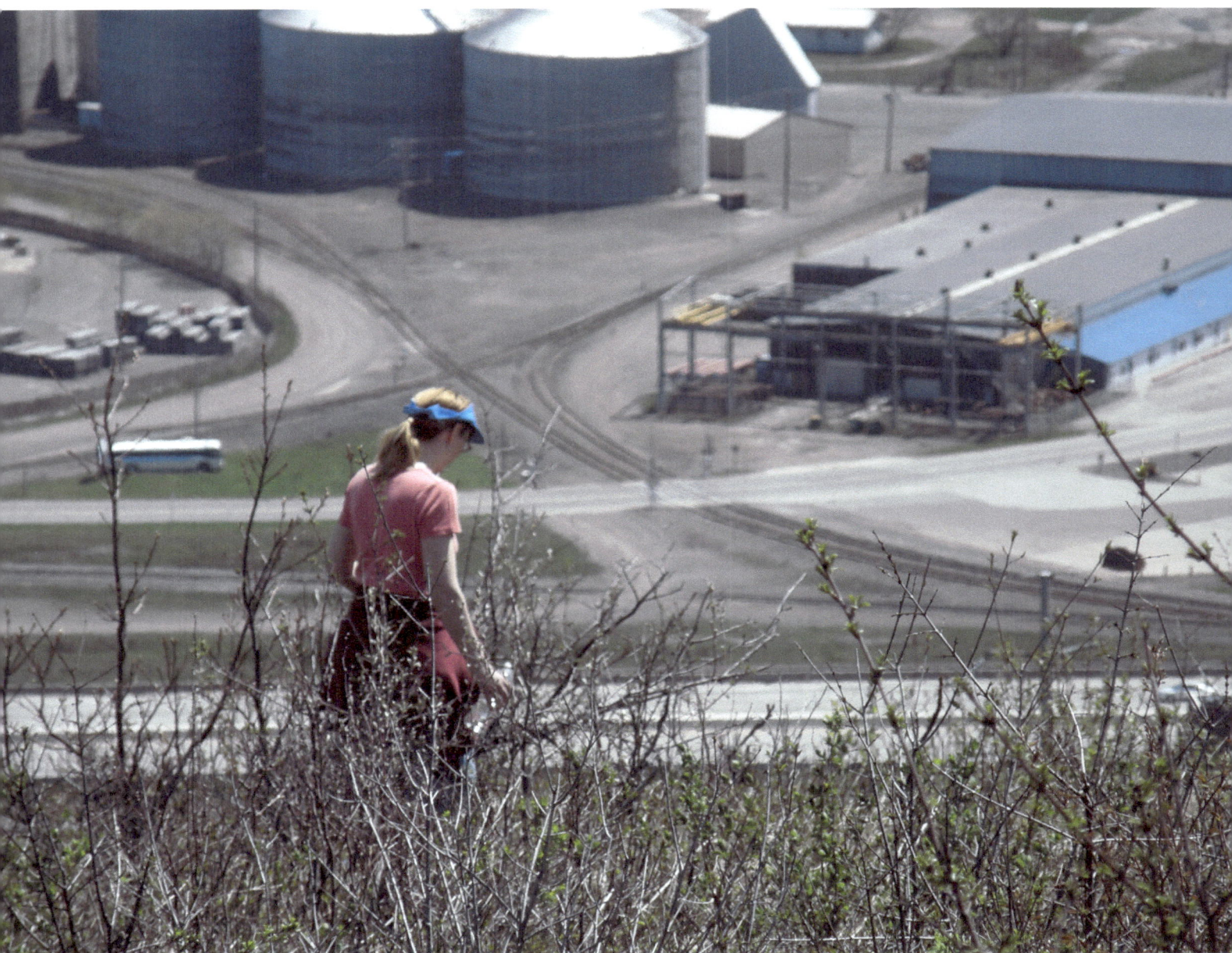
May 2014 – Enger Tower area, Duluth MN

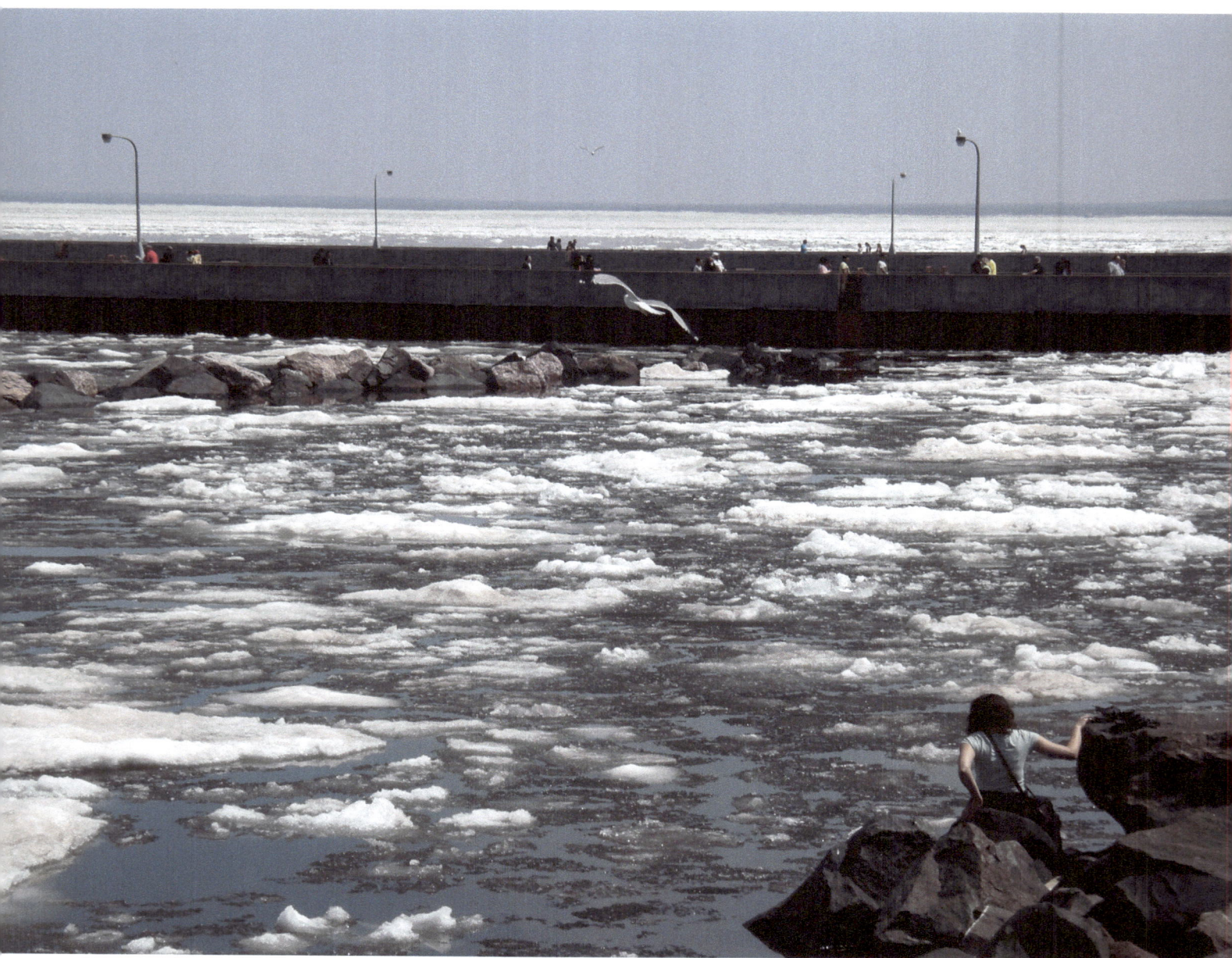
May 2014 – Canal Park, Duluth MN

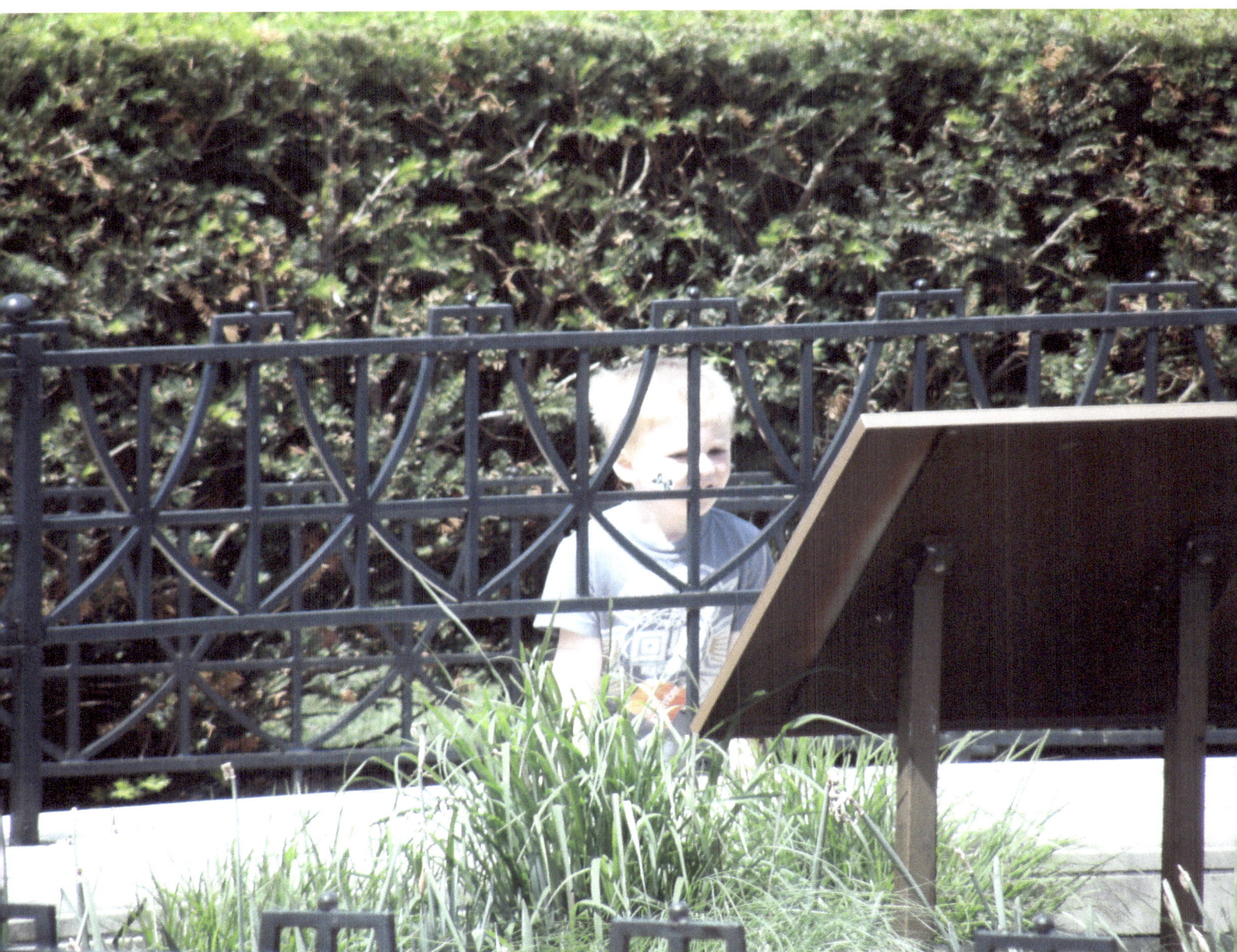
June 2014 – Field Museum, Chicago IL

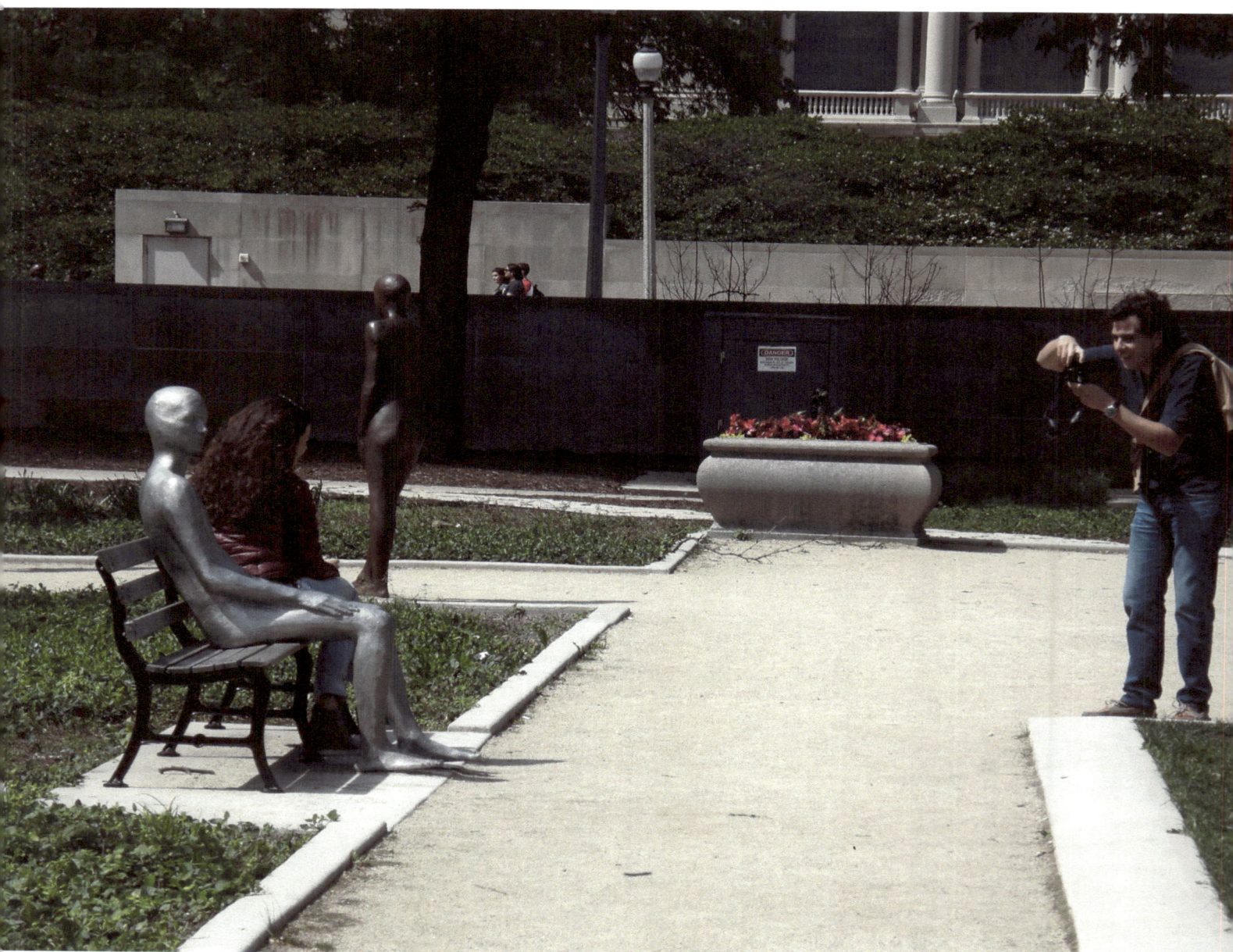
June 2014 – Millennium Park, Chicago IL

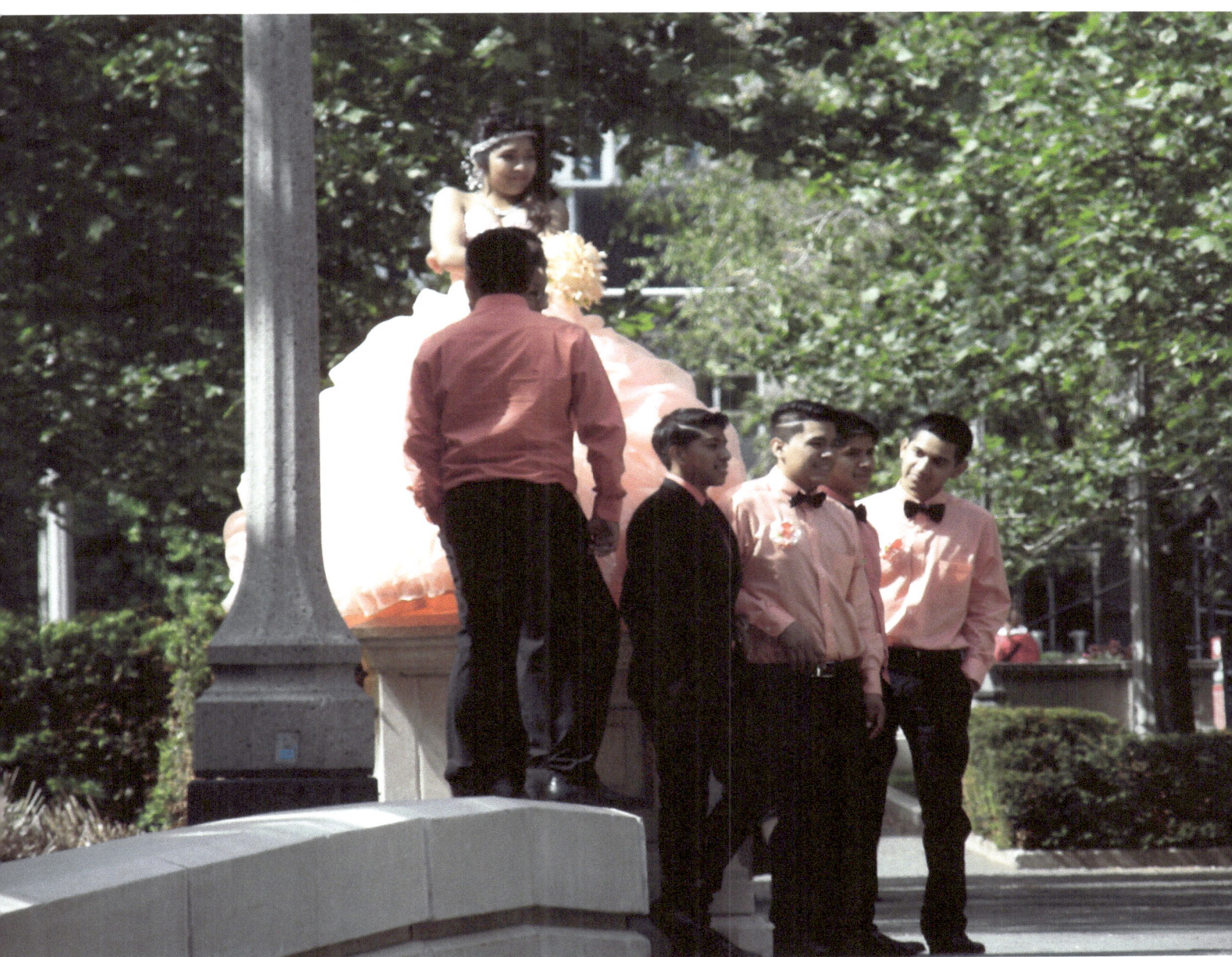

June 2014 – Millennium Park, Chicago IL

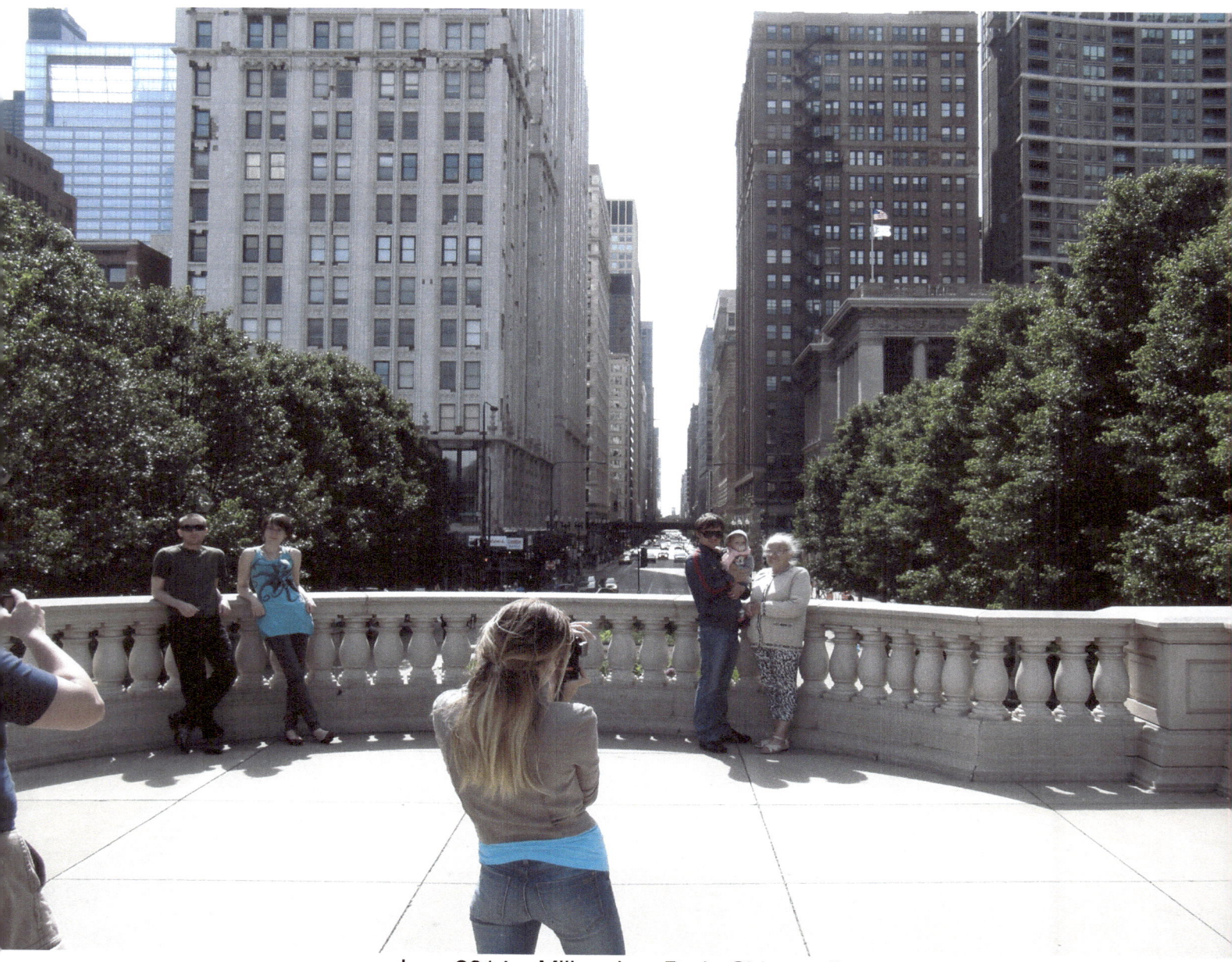
June 2014 – Millennium Park, Chicago IL

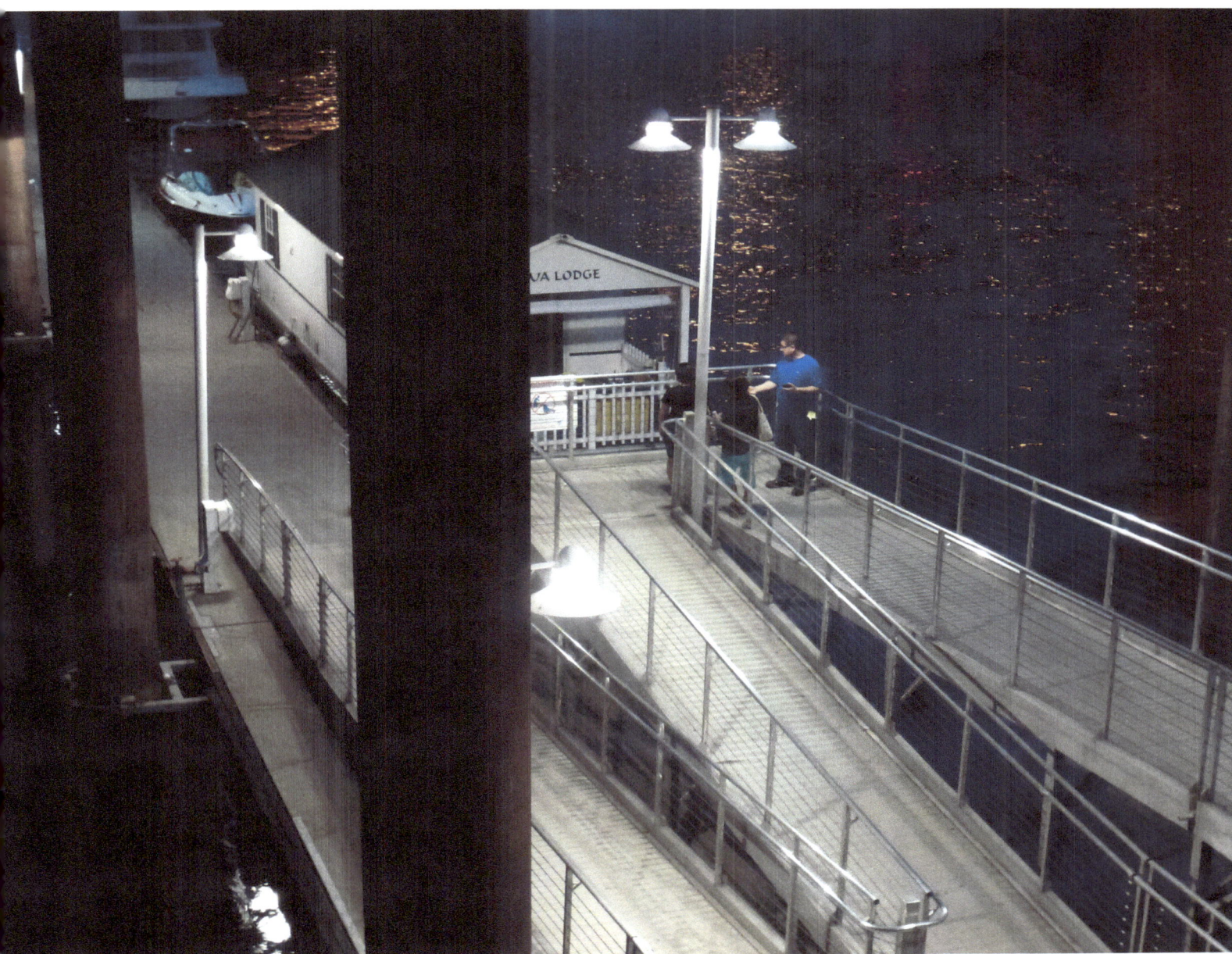

July 2014 – City Plaza Park, Sacramento CA

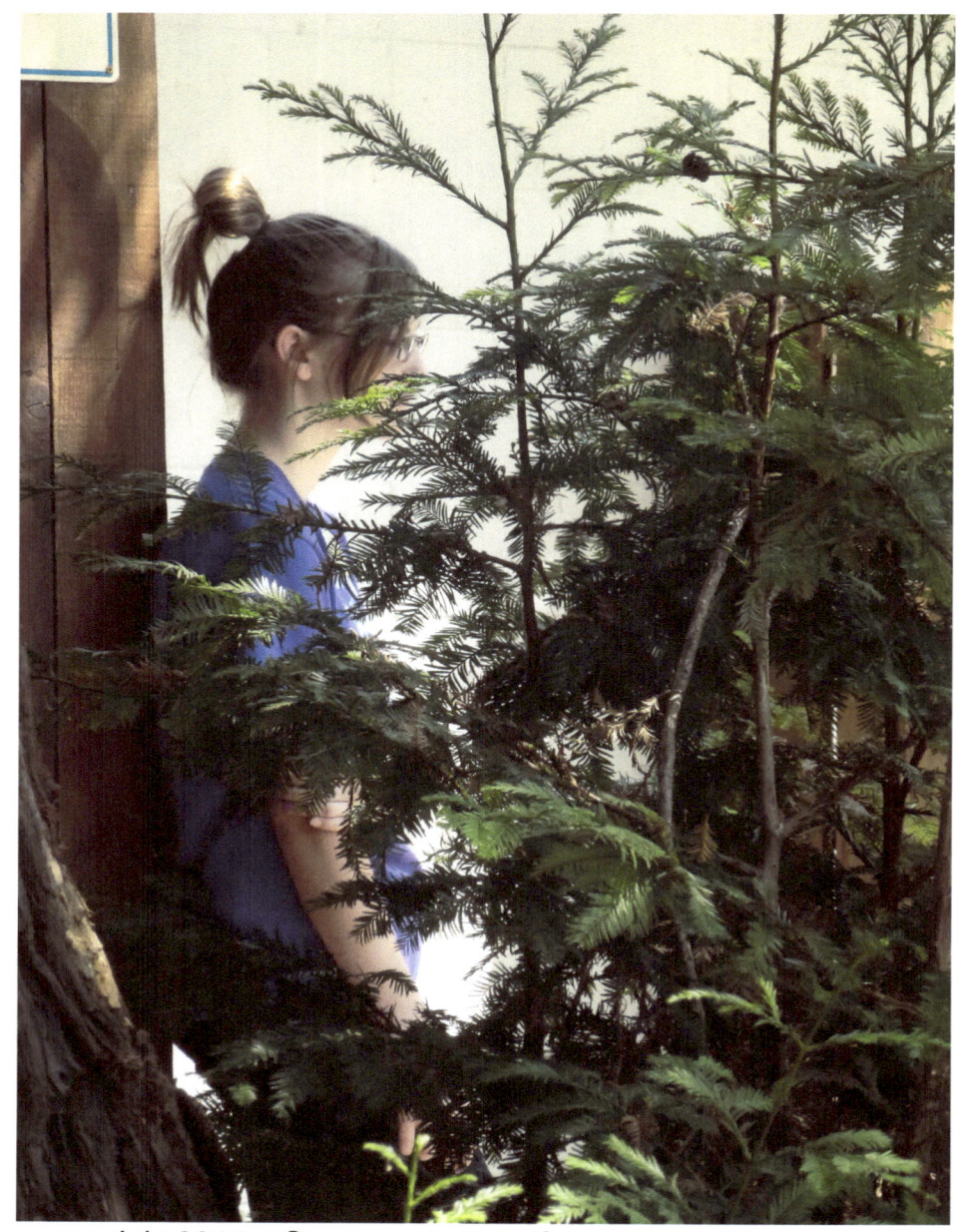

July 2014 – Sacramento Zoo, Sacramento CA

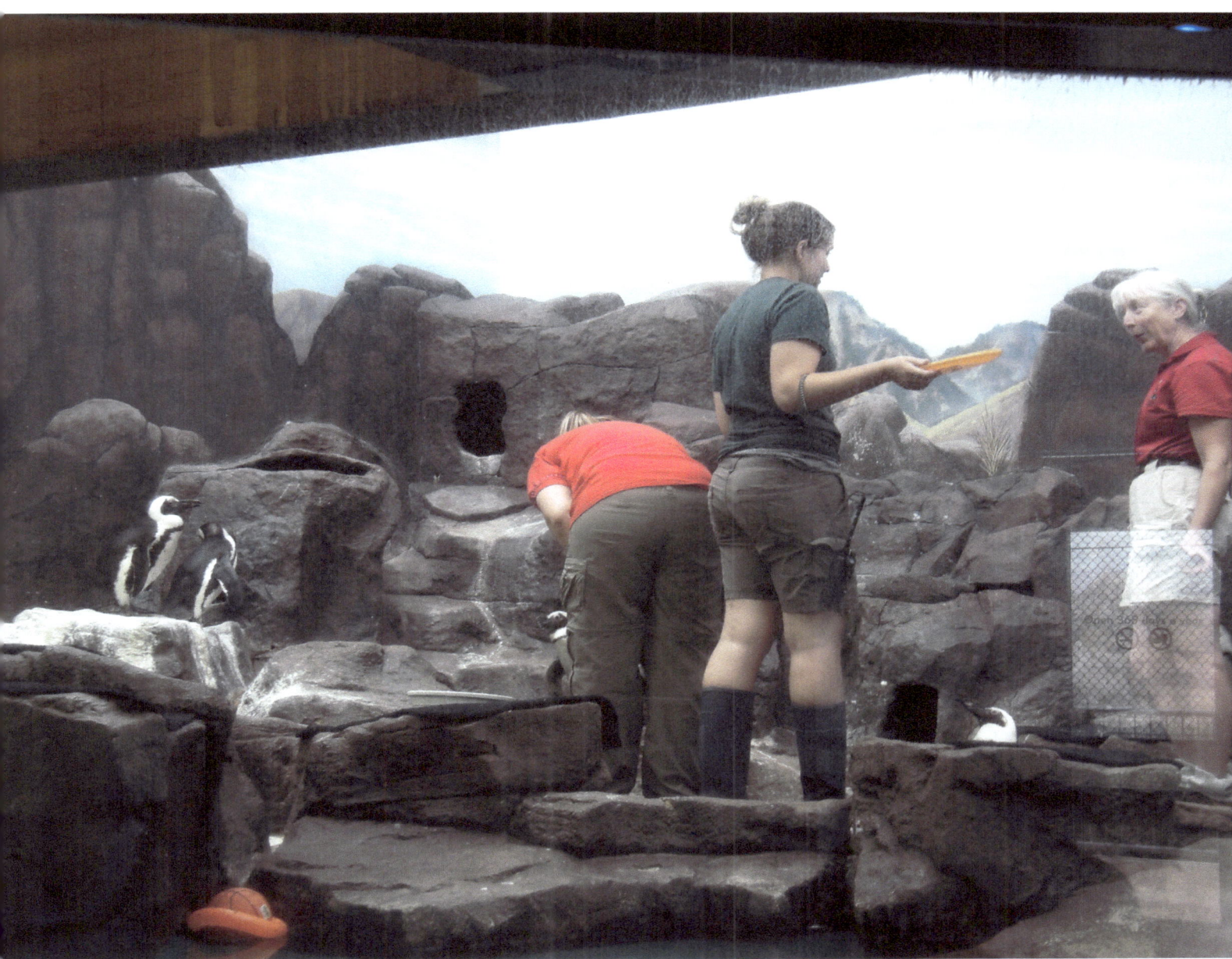

August 2014 – Como Park Zoo, St Paul MN

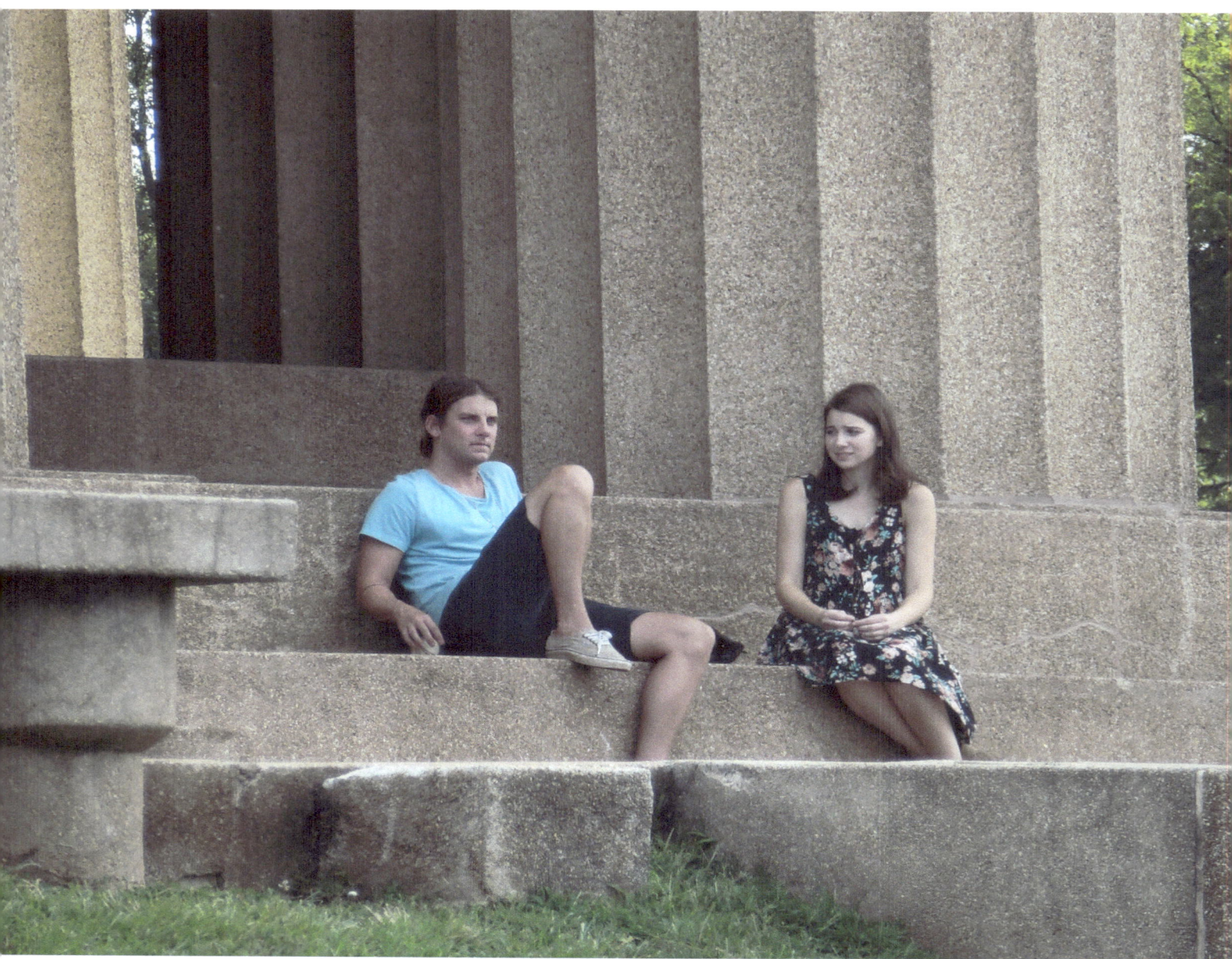

August 2014 – Centennial Park, Nashville TN

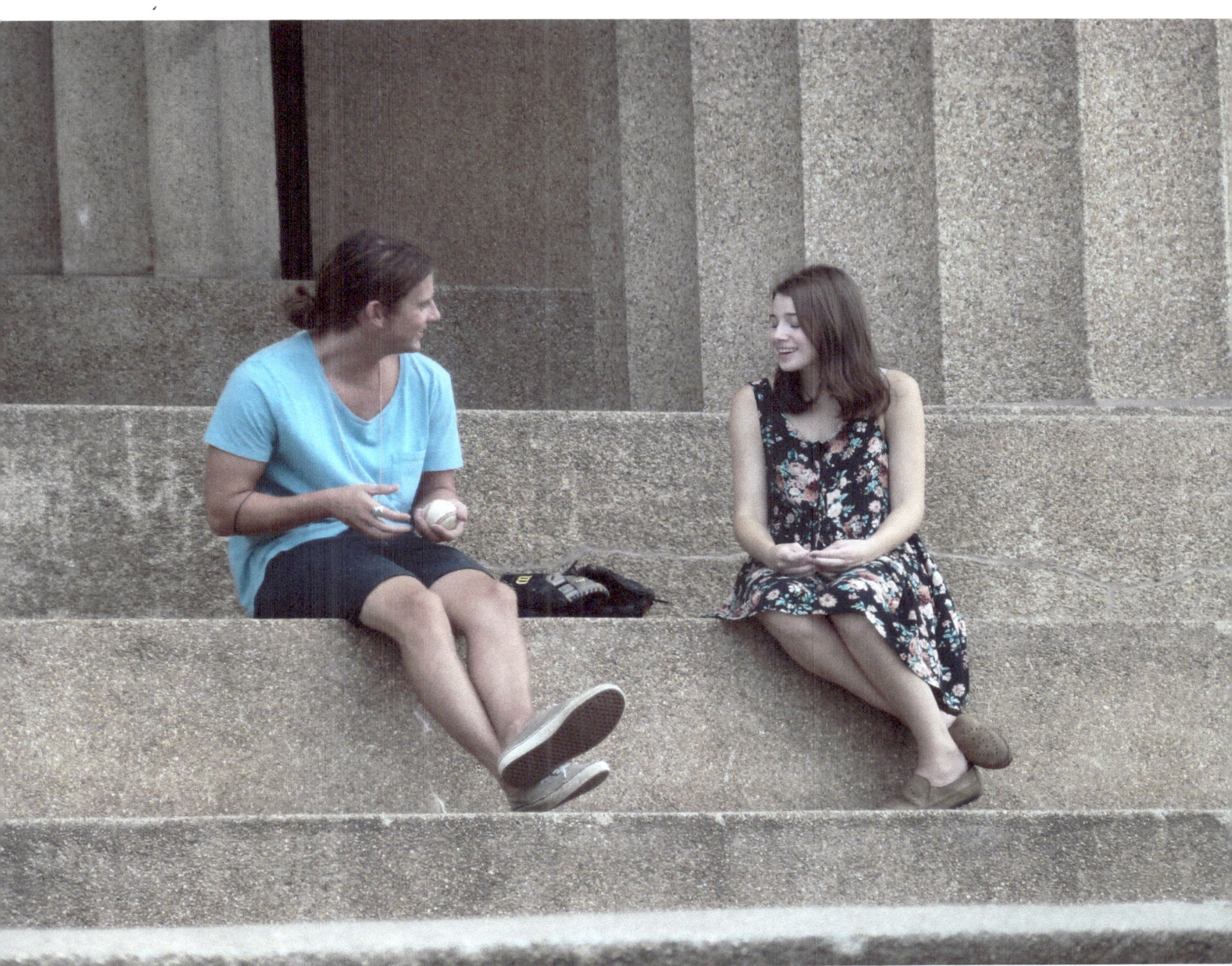
August 2014 – Centennial Park, Nashville TN

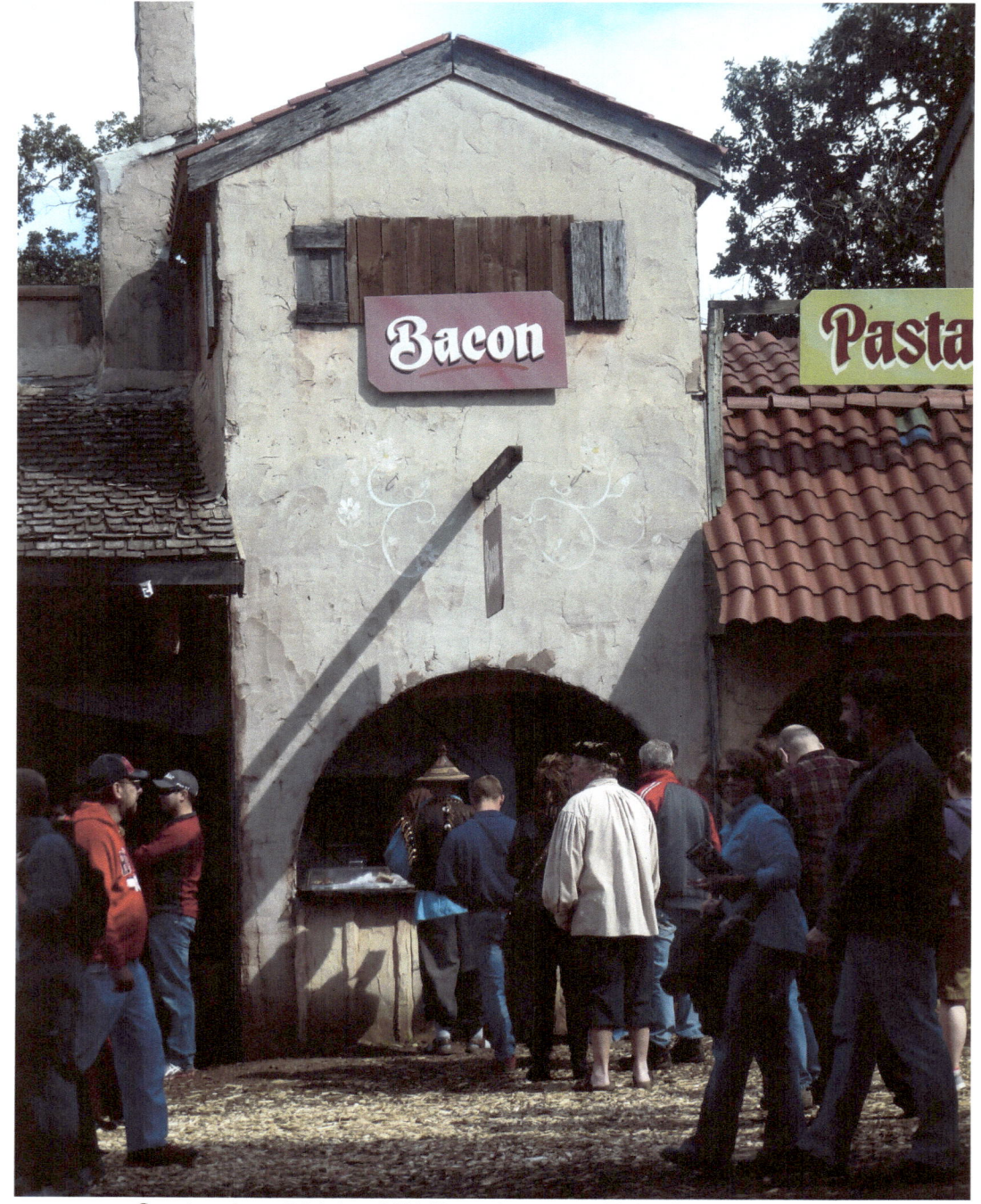

September 2014 – MN Renaissance Fair, Shakopee MN

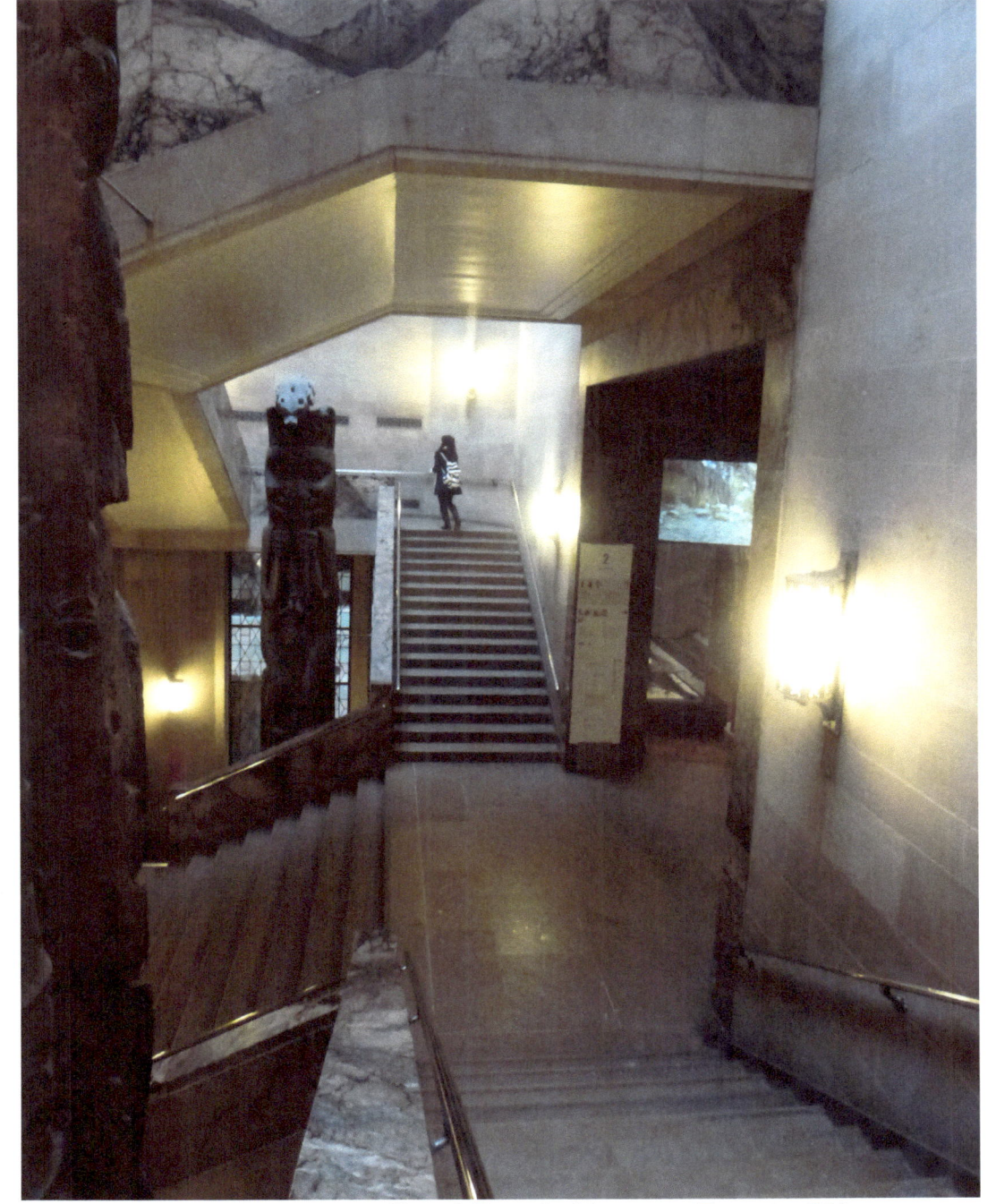
November 2014 – Royal Ontario Museum, Toronto ON

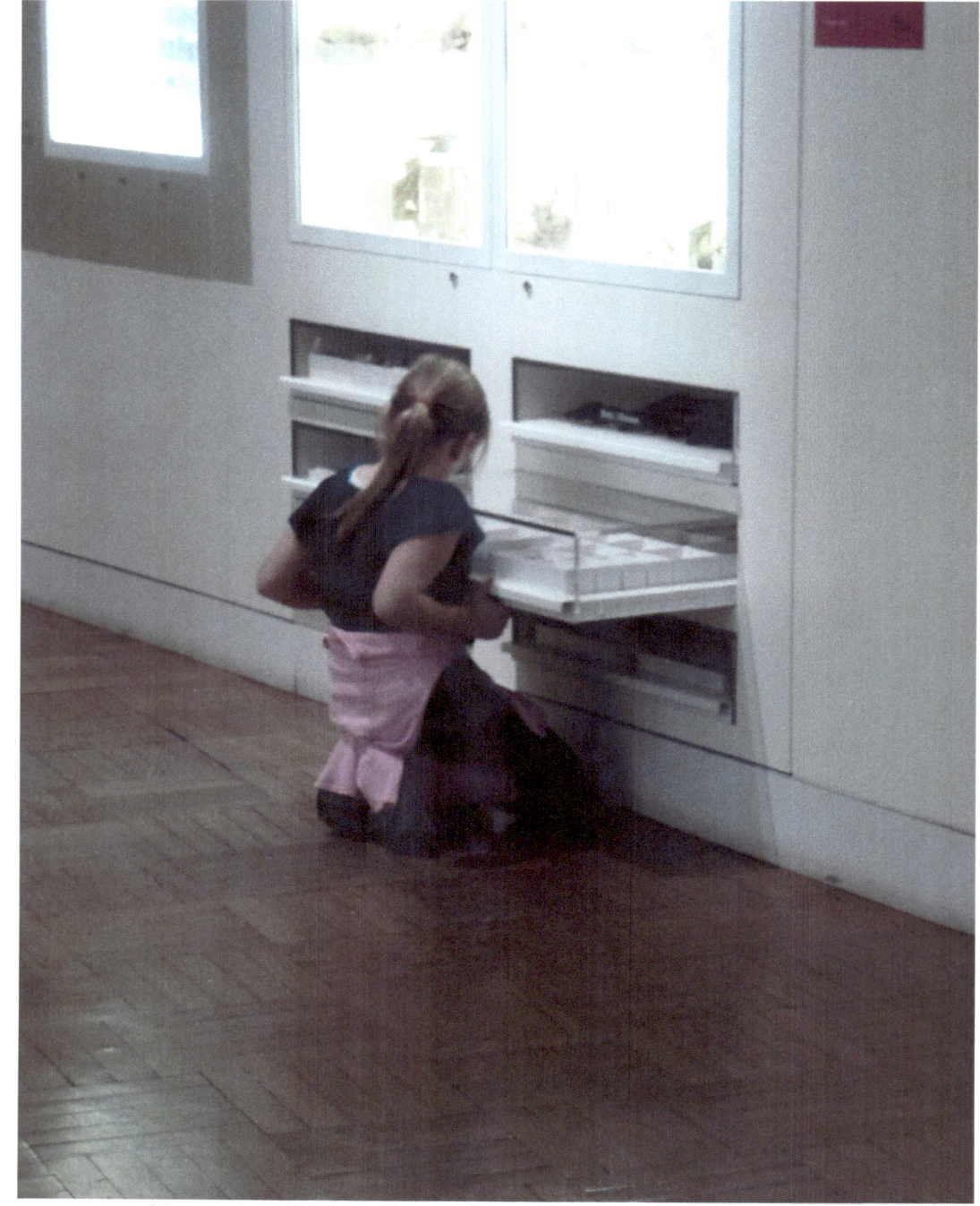

November 2014 – Royal Ontario Museum, Toronto ON

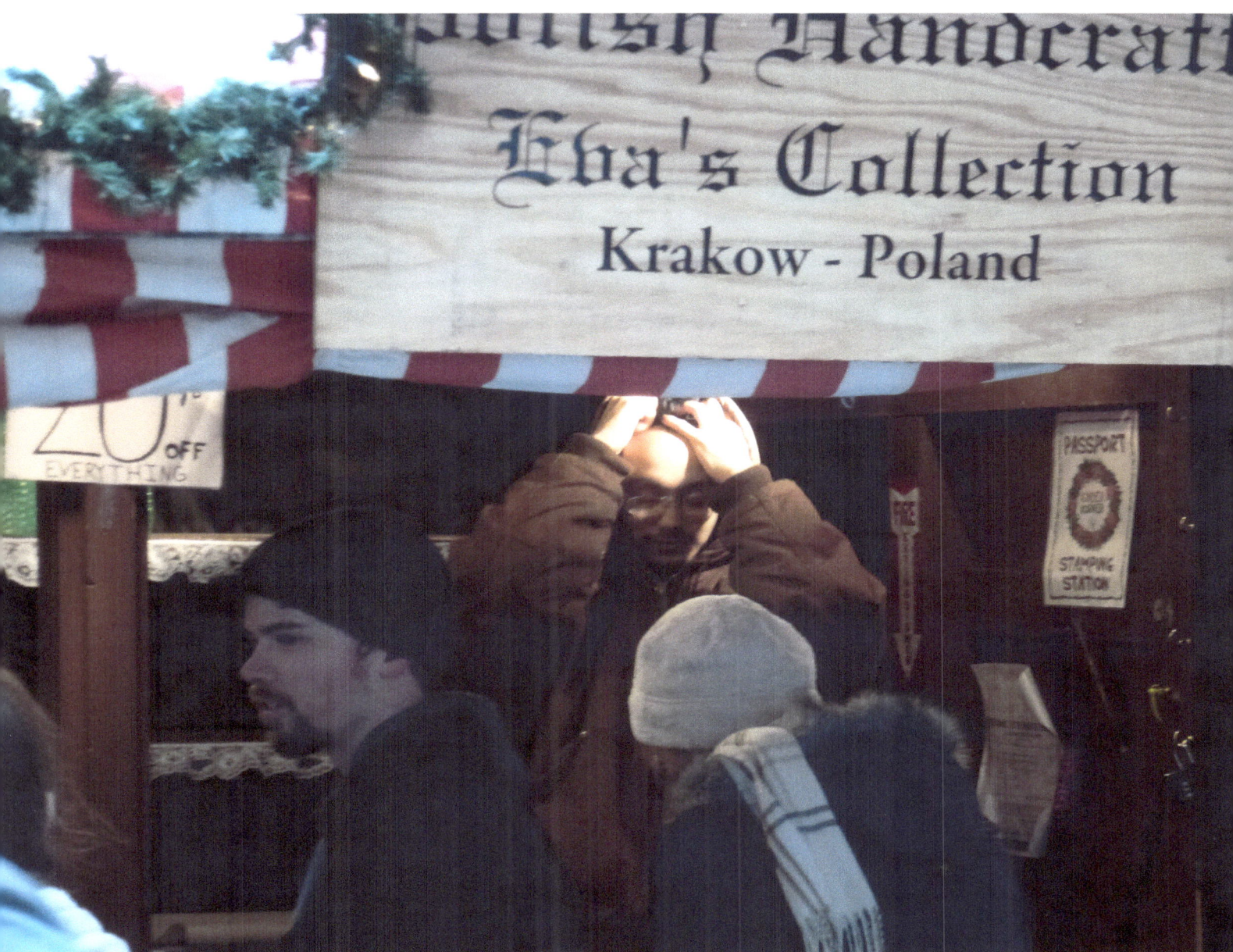
December 2014 – Christkindlmarket, Chicago IL

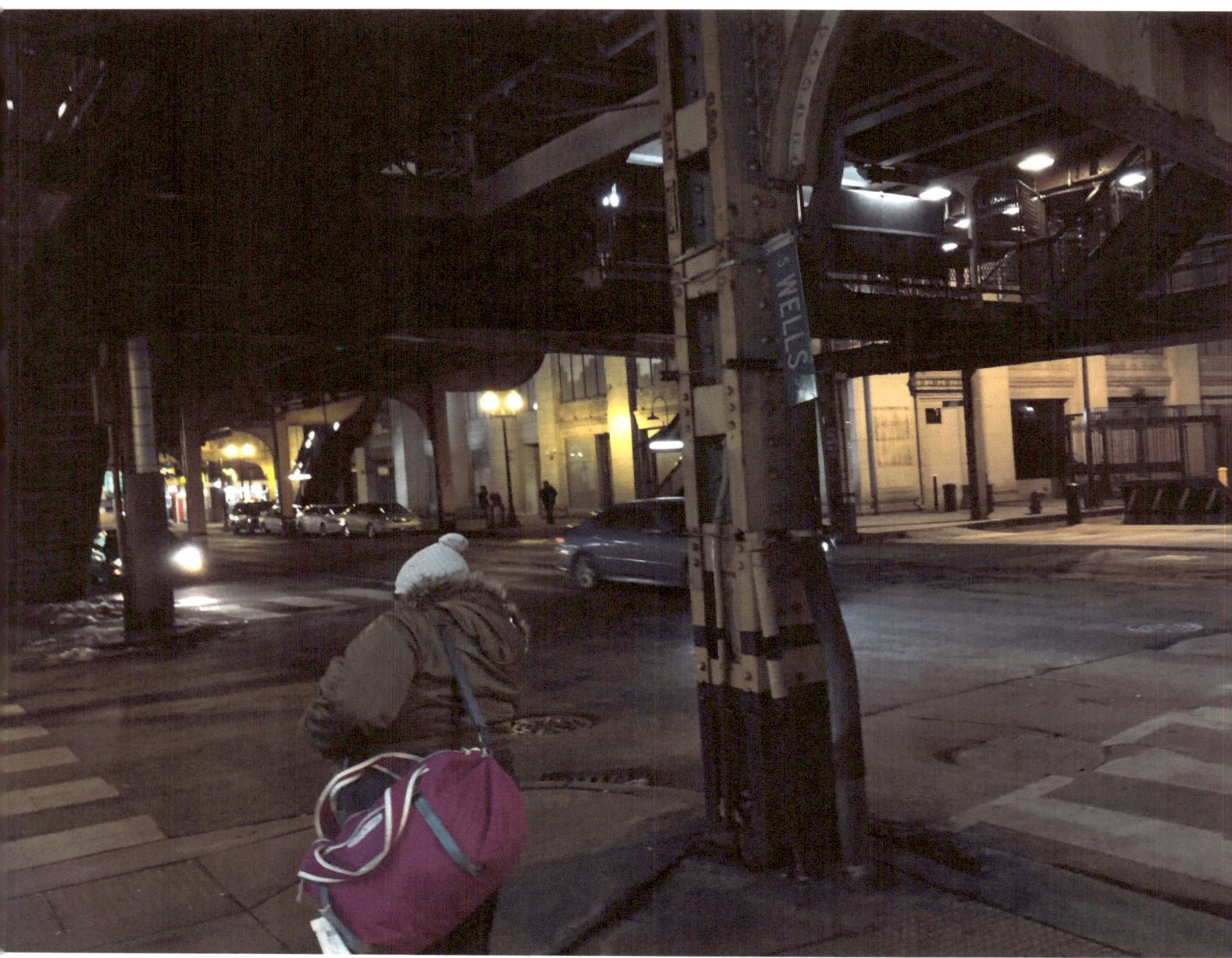

February 2015 – Chicago IL

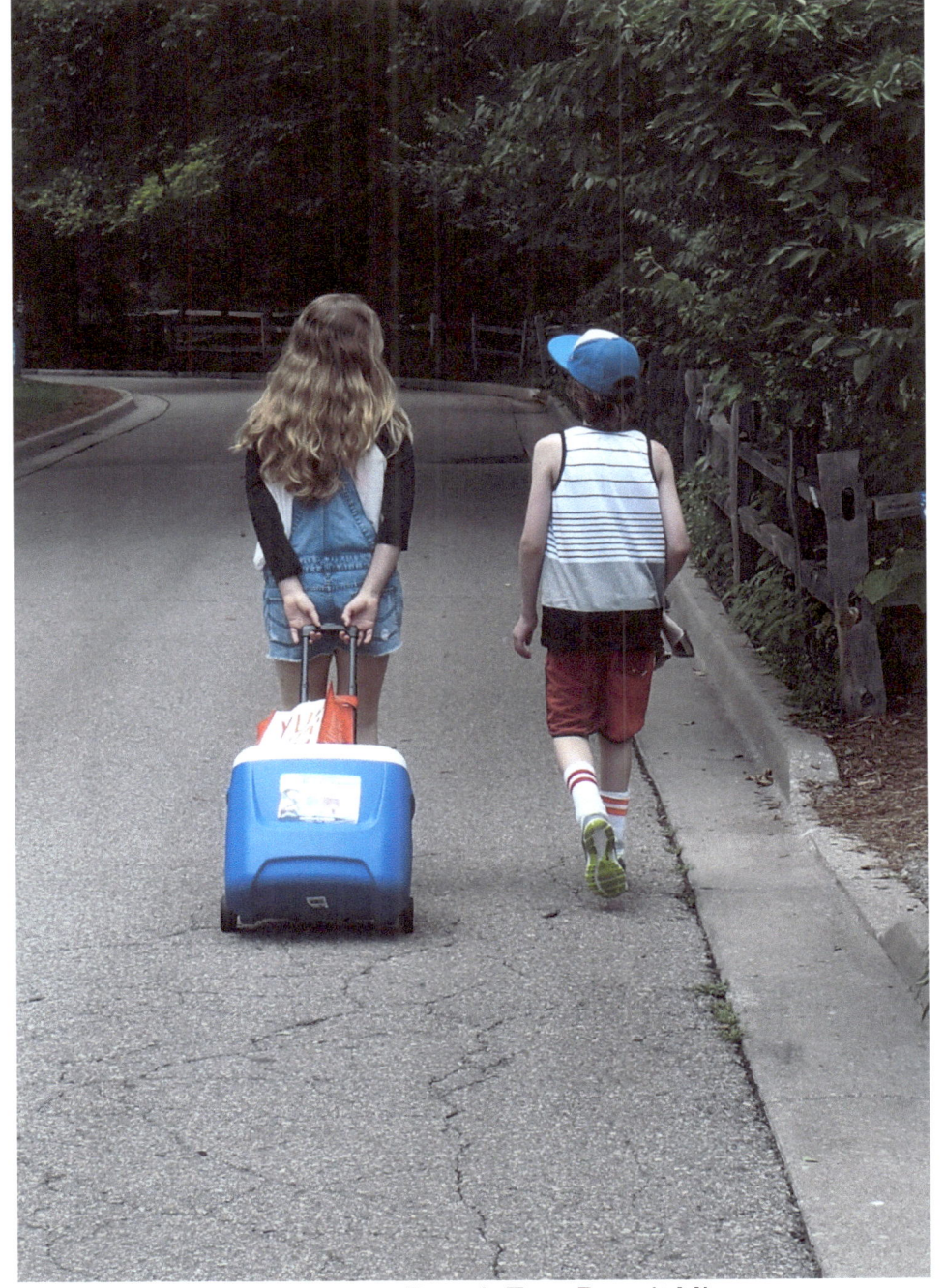

July 2015 – Detroit Zoo, Detroit MI

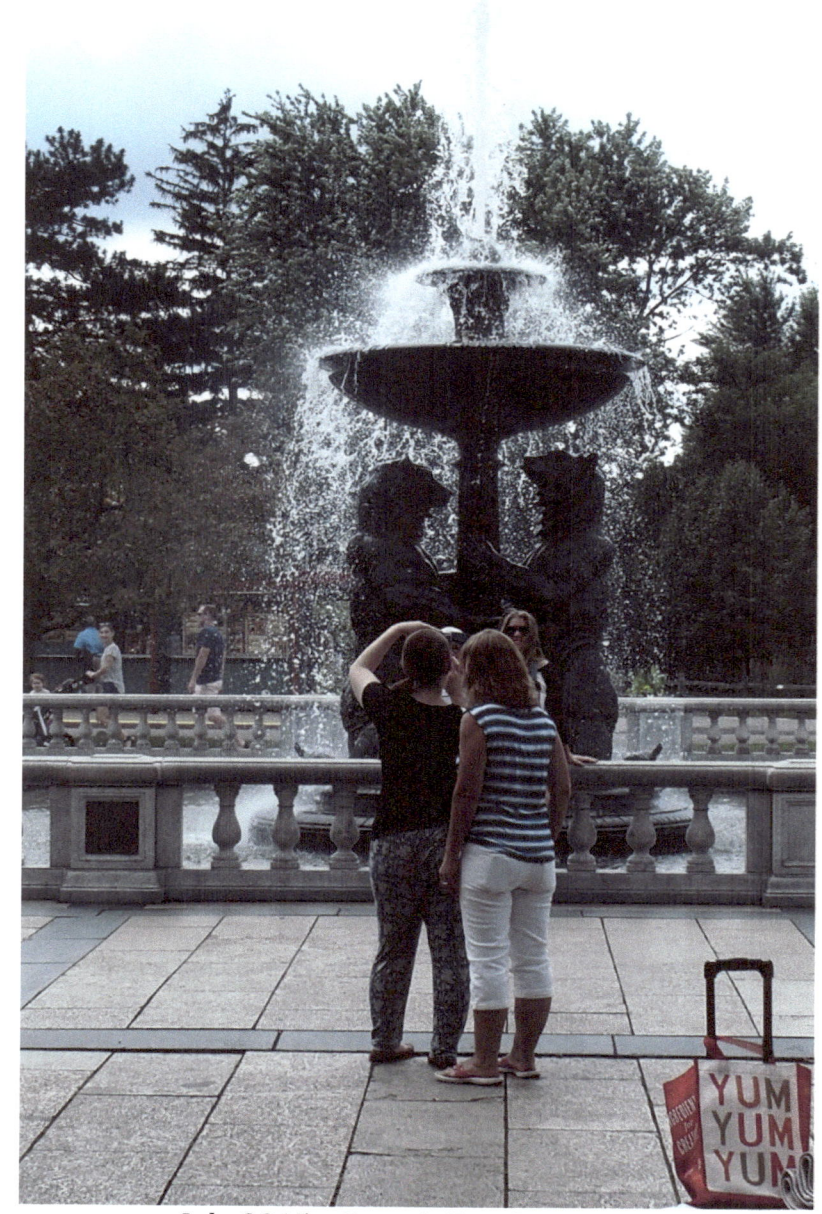

July 2015 – Detroit Zoo, Detroit MI

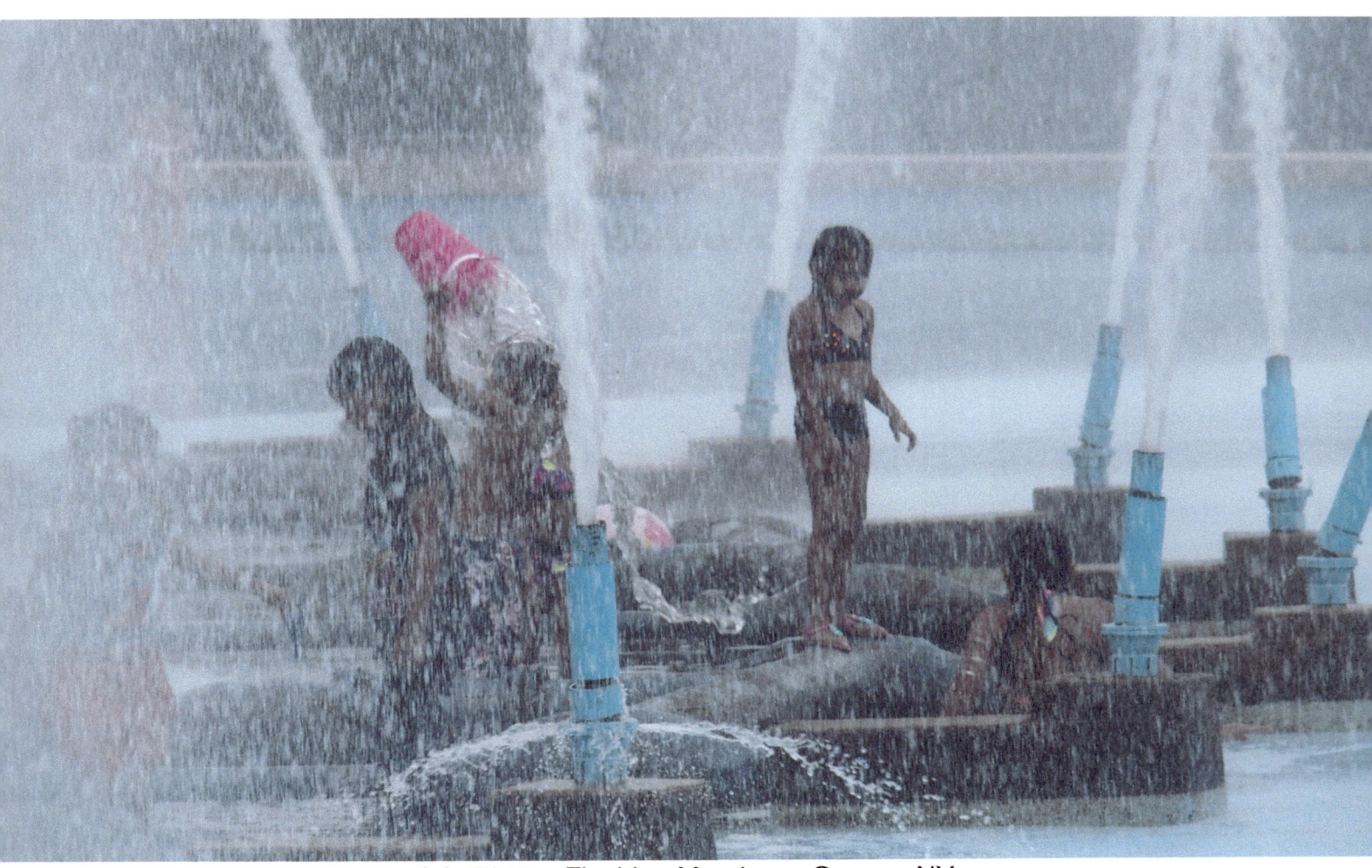
July 2015 – Flushing Meadows, Queens NY

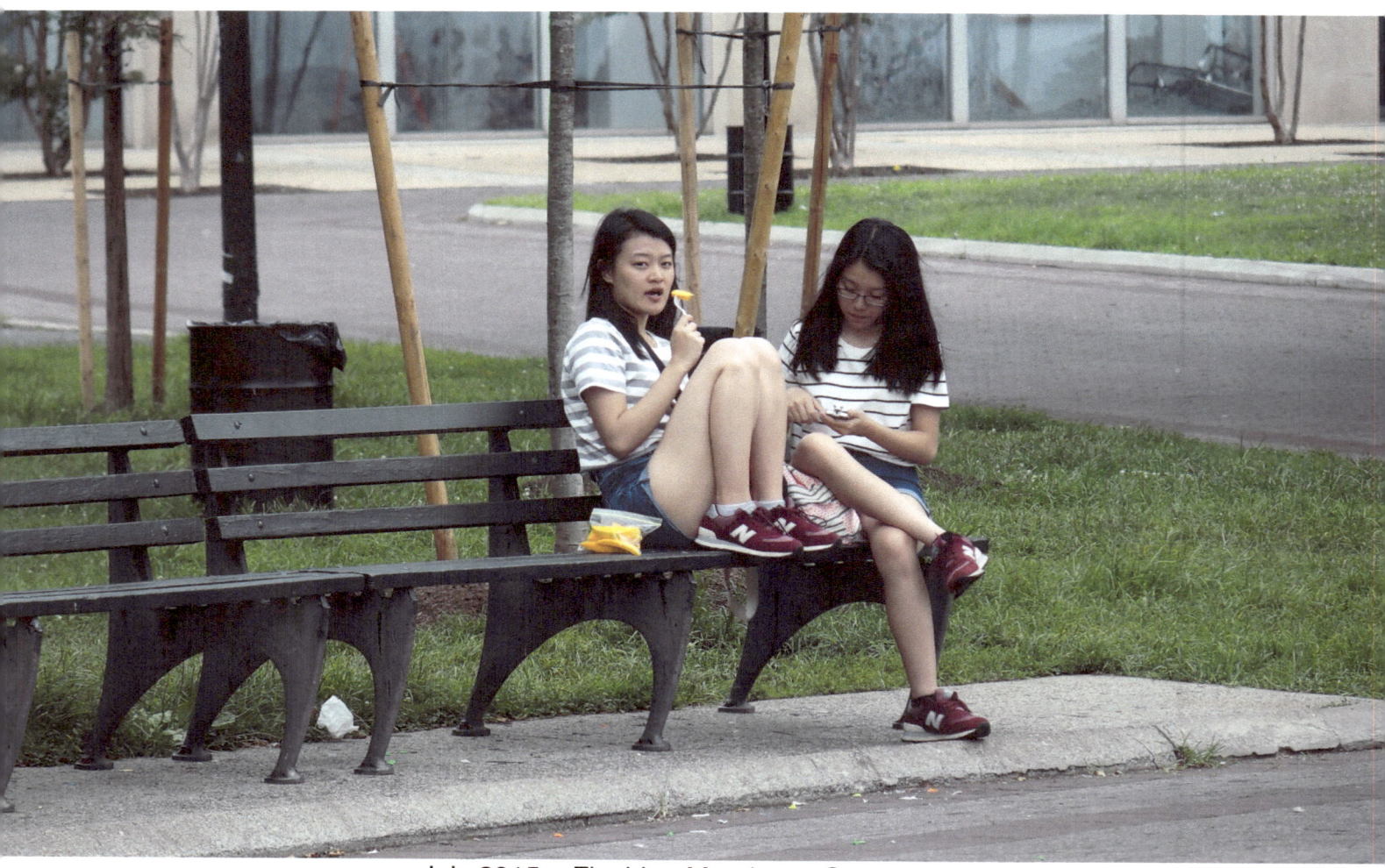

July 2015 – Flushing Meadows, Queens NY

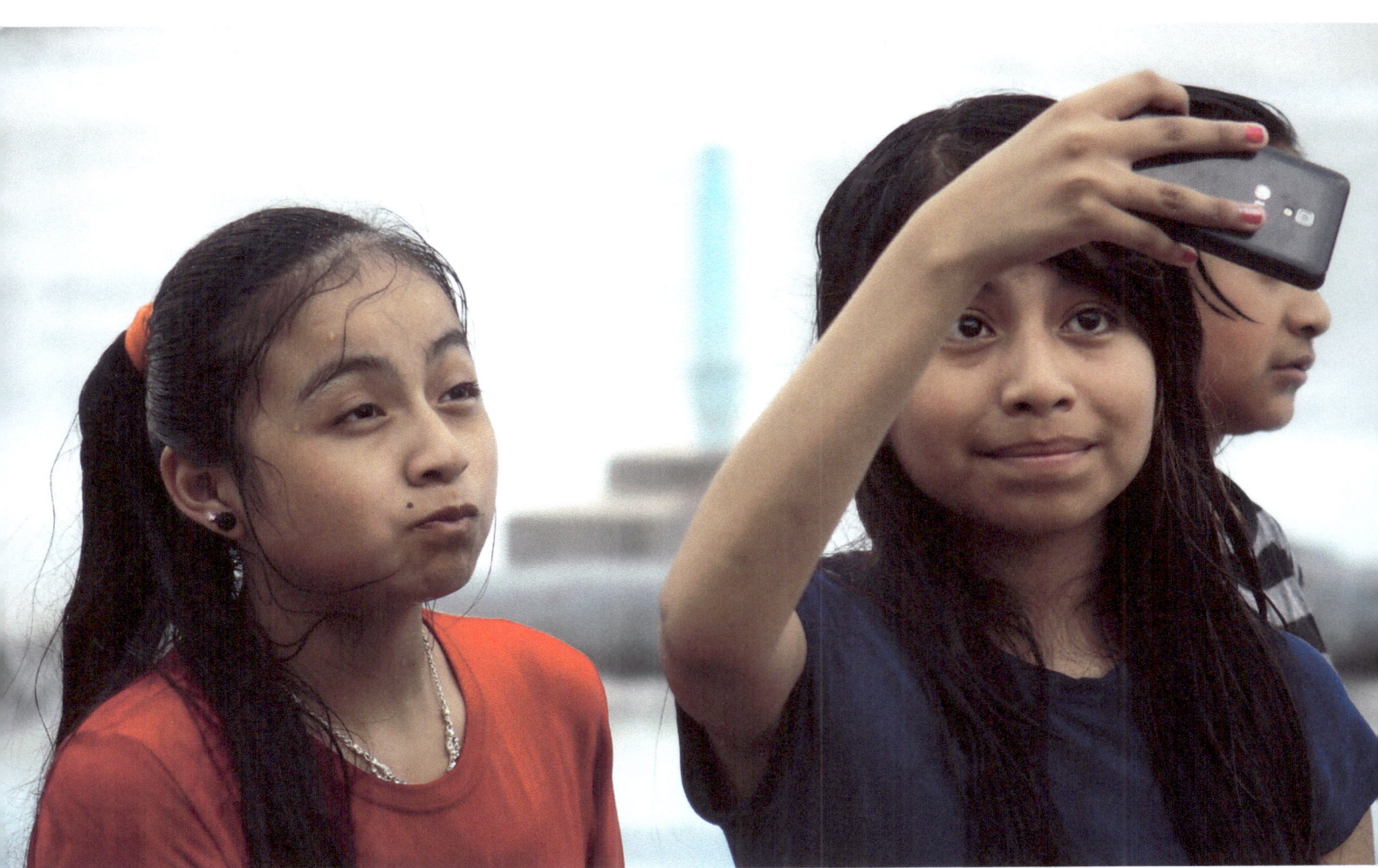
July 2015 – Flushing Meadows, Queens NY

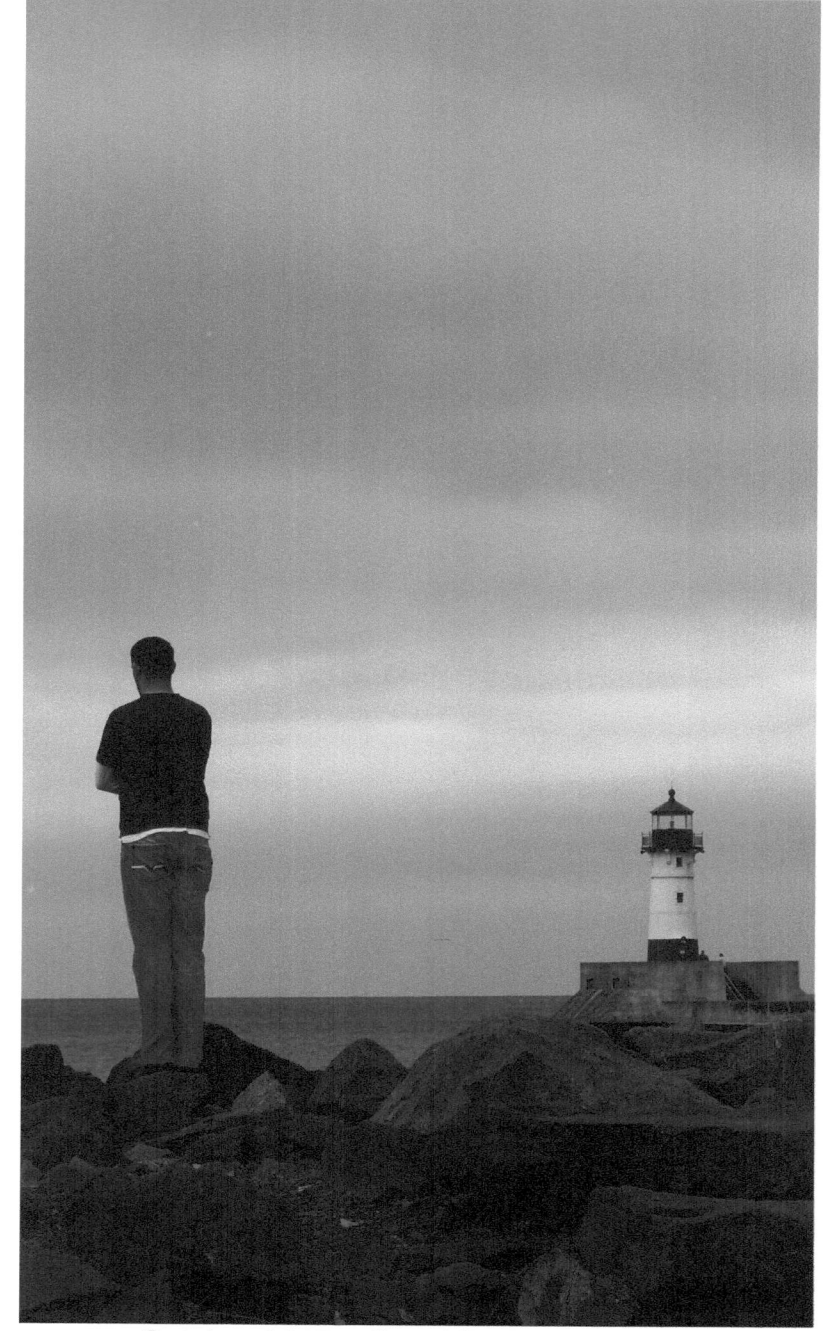

October 2015 – Canal Park, Duluth MN

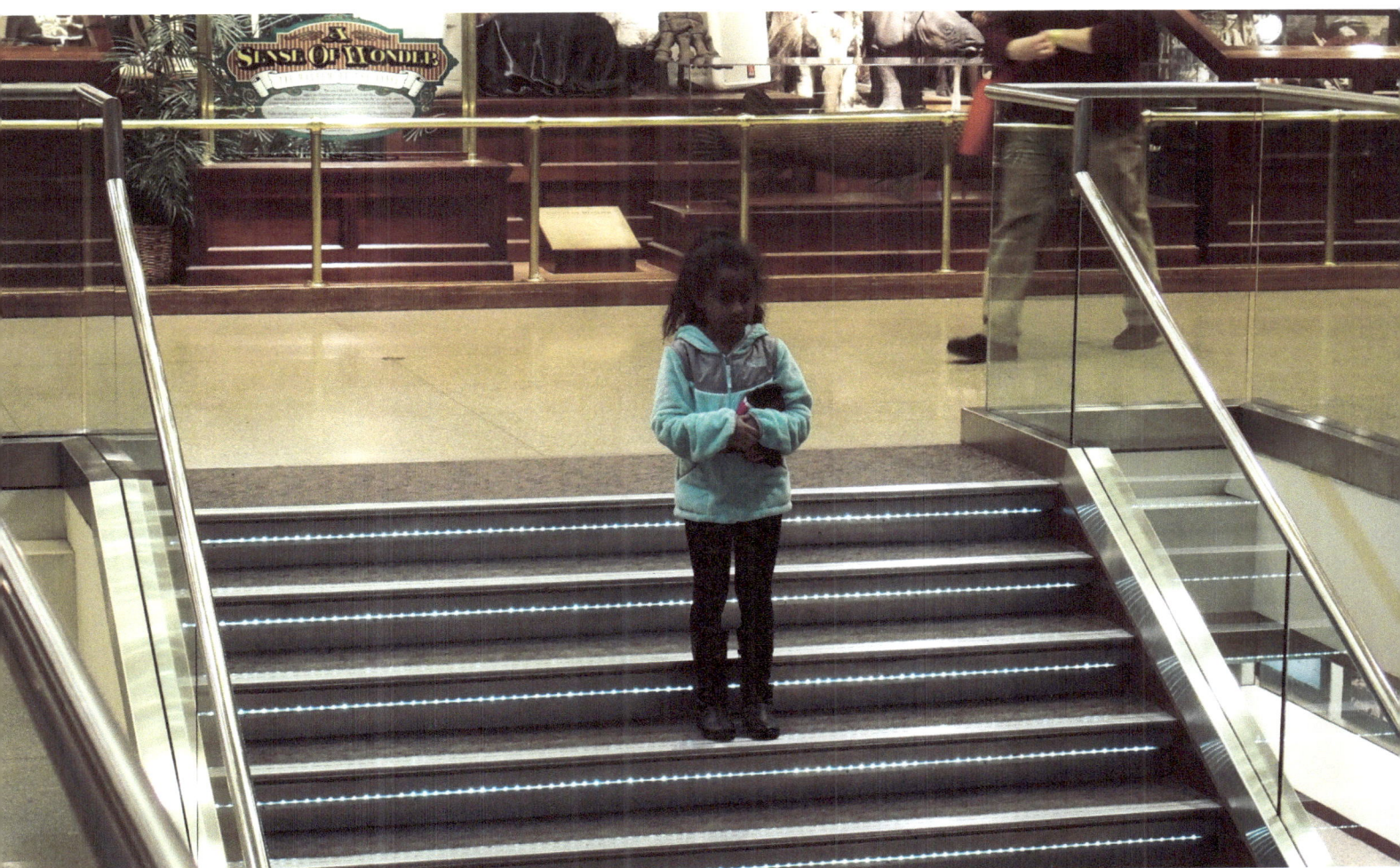
November 2015 – Milwaukee Public Museum, Milwaukee WI